IMAGES
of America

NATIVE SONS
OF THE
GOLDEN WEST

ON THE COVER: Members of the Native Sons of the Golden West show their pride in California's statehood as they carry a mammoth bear flag in an early-20th-century parade. Today, a century later, a 35-foot by 50-foot bear flag is a hallmark item that Native Sons continue to carry in many parades throughout the state.

IMAGES
of America

NATIVE SONS
OF THE
GOLDEN WEST

Richard S. Kimball and Barney Noel

ARCADIA

Published by Arcadia Publishing
Charleston SC, Chicago IL, Portsmouth NH, San Francisco CA

Printed in Great Britain

Library of Congress Catalog Card Number: 2005934834

For all general information contact Arcadia Publishing at:
Telephone 843-853-2070
Fax 843-853-0044
E-mail sales@arcadiapublishing.com
For customer service and orders:
Toll-Free 1-888-313-2665

Visit us on the Internet at www.arcadiapublishing.com

CONTENTS

ACKNOWLEDGMENTS

Most of the photographs used in this book have come from the archives of the Native Sons of the Golden West. We thank Millard Smallin, the organization's curator of artifacts, for the work he has done throughout the years in organizing the materials so that we could find what we needed. Native Sons office manager Dominica Lau was helpful as always in making clerical tasks easier. A number of people helped us find materials to supplement the collection. Among them were the longtime managing editor of the *Native Son* newspaper, Fred Codoni; Bob Santos; Paula Wong; Fred Schram; Mike Jack; Dora Garcia; Jim Smith; Dave Allen; Don Brown; Millard Smallin; and Bill Geisner. The efforts of Tom Fong and James Stich, recent grand historians, also made our work easier.

INTRODUCTION

A long time ago, before there was television and before anyone had heard of virtual reality, people would gather in their homes to listen to player pianos. Perhaps they would crank up a phonograph and listen to music offered by John Philip Sousa's band, the Victor Military Band, or Irish tenor John McCormack. Maybe they listened to recordings of vaudeville sketches by Joe Weber and Lew Fields, or by Scottish singer-comedian Harry Lauder.

Or perhaps they would go to a lodge meeting where they would get together with friends to plan for an upcoming civic holiday. The pageantry that accompanied such holidays was a major form of entertainment as the planning of such an event might take months. The panorama of it could be replayed in the minds of spectators and participants alike for many months afterward—until it was time to begin planning for the next year's celebration all over again.

This book is going to reawaken some of those images by showing how the Native Sons of the Golden West, an organization that still is lively today, celebrated California's statehood, especially on Admission Day, a holiday that once ranked as a banner date in the calendars of many Californians. It was an era when the California legislature decreed, "All public offices of the state and all state institutions, including the state university and all public schools in the state shall be closed on the ninth day of September of each year, known as Admission Day."

Who are these Native Sons of the Golden West, and why have they always considered the state in which they were born to be so special? Each year, many thousands of people visit sites that are fundamental to understanding California's history, places such as Sutter's Fort in Sacramento, the mecca for weary pioneers who came overland to California in the days before the gold rush; the Custom House in Monterey, the oldest public building in California; and Fort Ross, the settlement in Sonoma County enclosed by redwood timbers 8 inches thick and 15 feet in height, built by Russians beginning in 1812.

What many visitors to the landmarks don't realize is that these and a multitude of other similar monuments to California's past would not be available today for their education and enjoyment had it not been for the efforts of the Native Sons of the Golden West. When historic sites such as these lay completely neglected, falling into ruin, the Native Sons acquired the properties, helped restore them, then turned them over to the State of California so future generations could experience and treasure them.

The Native Sons also helped build monuments—from the gold discovery site at Coloma, to the location of the tragic encampment of pioneers at Donner Lake, to the plaza in Sonoma where the bear flag was unfurled—so that vital incidents in California history would not fade from memory.

The Native Sons was organized in 1875 by a few like-minded people who believed the memories of the gold rush era and early statehood would melt away unless people born in the Golden State protected them. Originally, it was a society confined to San Francisco, but in 1877 a chapter (chapters are called "parlors") opened in Oakland. A Sacramento parlor opened in 1878, and

the first Grand Parlor (as the annual state conventions are called and what used to refer to the parent order) was held that year. In 1893, the organization doubled its membership to nearly 700, and blossomed from there.

Its objectives are still as important today as in the past. At the dawn of the 21st century, nearly 9,000 men and women, born in California and who can trace their ancestries to all corners of the earth, are members of the Native Sons. They are still carrying forward the important duty of protecting and proclaiming California's history.

Just as they have been doing for more than 130 years now, Native Sons of the Golden West continue to place plaques and markers at places of historic interest. And today, as has been true for more than a century, Native Sons are a featured in many parades throughout the state. From the Carrot Festival in Holtville to the Corn Festival in La Habra, from Fairfax Days in Marin County to the Italian Picnic in Sutter Creek, at May Day in Los Banos, or at the Fourth of July in Redwood City, a person is likely to see Native Sons carrying their hallmark world's largest bear flag (35 by 50 feet) in parades.

Throughout the years, in the heyday of parades and parading, Admission Day served as a crowning point of Native Sons annual activities. Simply put, Admission Day is California's birthday; it is the anniversary of the date upon which President Millard Fillmore signed an Act for the Admission of California into the Union. Every state, of course, has an anniversary marking the day it entered the union, but Californians believe theirs has a special meaning.

The state was uniquely admitted without any probationary period of territorial childhood. In the era immediately following the Unites States's acquisition of land that would become California, its sparsely settled communities were devoid of civil government. In December 1848, President James K. Polk appealed to Congress to establish a "stable, responsible and free government" for California, but Congress, deadlocked over the issue of slavery, did nothing. Meanwhile, the gold rush had begun. Tens of thousands of immigrants suddenly appeared in the land, improvising settlements where none existed before. It soon became evident that something had to be done— and soon—to maintain a fair degree of order. Citizens in San Jose held a meeting to form some kind of provisional government "for the better protection of life and property." Similar meetings soon followed in Sacramento, San Francisco, and Sonoma. Responding to their pleas, Military Governor General Bennett Riley authorized an election to choose delegates to a Constitutional Convention. The delegates met at Colton Hall in Monterey, and quickly by a vote of 28 to 8 scrapped the idea of forming a territorial, as opposed to state, government.

Things moved along rapidly. On October 13, 1849, the convention finished its work and by a vote of 12,872 to 811, California citizens ratified the new Constitution and elected the first state officials. On December 15, the legislature met and the new state government began functioning almost a full nine months before Congress, confronted with an actual state government existing, formally legally recognized California as a state.

The energetic, take-charge spirit that gave birth to the state of California has characterized it ever since and is reflected like a badge of honor by the Native Sons of the Golden West as, year after year, they commemorate the romantic and colorful history of the state of their birth. We hope this book will take you on a journey with this cavalcade of celebration as it has unfolded across the years and leave you with a better appreciation of California's golden past.

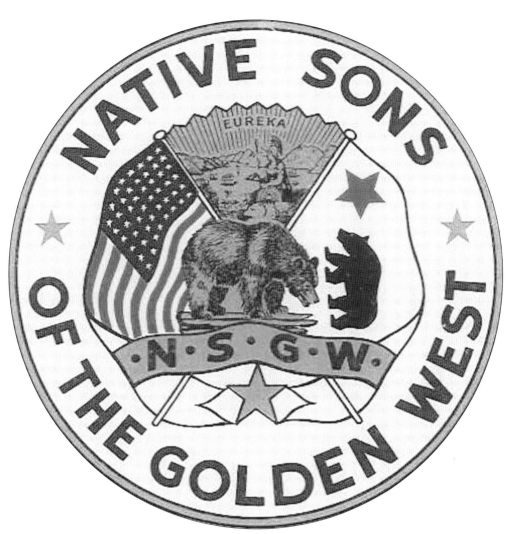

The insignia of the Native Sons of the Golden West, reflecting the visual themes of the California state seal flanked by the American and bear flags, emphasizes the importance the fraternal order places upon the entry of California into the union of states. Native Sons consider it to be a cardinal and decisive event in the history of their native land.

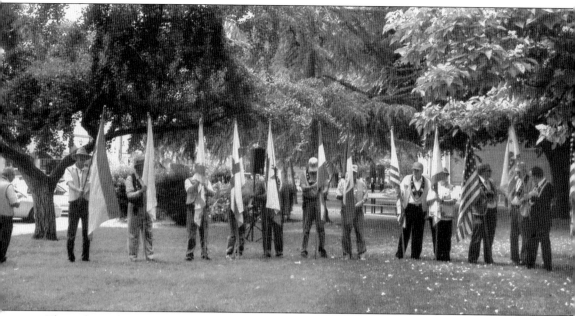

Throughout the years, the Native Sons of the Golden West has placed its primary emphasis upon California's admission to statehood as a crucial and decisive event in the land's history. Still, as its annual Flag Day ceremony colorfully shows, the organization places importance on bringing to mind all eras of California's history. By coincidence, June 14—celebrated throughout the United States as Flag Day because on June 14, 1777, the Continental Congress adopted a resolution designating the Stars and Stripes as the official flag of the united 13 former British colonies, is also the anniversary of the first raising of the bear flag, California's state flag, which was first unfurled at Sonoma's plaza on June 14, 1846, by a group of American settlers who were discontented with the governance provided by Mexican authorities ruling California at the time. Each year, the Native Sons gather at Sonoma to commemorate that event, displaying a succession of historic flags that have flown over California. Among the flags displayed during the annual "history lesson in a nutshell" are those of the Spanish empire, which flew over the land from 1542 to 1822; the flag of England, planted at Drake's Bay by Sir Francis Drake in 1579; the flag of Russia that flew over the Russian American Company's trading post at Fort Ross from 1812 to 1841; the Buenos Aires flag that flew over California's capital of Monterey for 16 days in 1818 when pirate (or privateer, depending on one's point of view) Hypolite Bouchard captured the city; the Mexican flag that was raised over California when Mexico gained its independence from Spain in 1822; the bear flag; and several versions of the American flag. New stars were added to the American flag on the Fourth of July following the admission of new states to the union; thus the 31st star, representing California, was officially added to the flag on July 4, 1851, following California's admission to statehood on September 9, 1850. The American flag had been modified to add additional stars on 14 occasions since then. The biggest one-time change occurred on July 4, 1890, when five new stars were added all at once to commemorate North Dakota, Montana, Washington, and Idaho, all of which had been admitted during the preceding year.

One

CELEBRATING
AND PARADING

Annually, when members of the Native Sons of the Golden West install their statewide officers (called "grand" officers), they are reminded that "some of the most beautiful traditions are kept alive by these [parades], and they should be conducted with an imposing dignity in keeping with the widespread expectations of a people whose love for the past is reflected in the Order of the Native Sons of the Golden West." So why does this organization attach so much importance to parading? There can be many answers, but the main is that it all began with a parade.

Albert M. Winn, a native of Virginia, came to California in 1849 and soon seemed to have an interest in an incredibly wide range of civic affairs. He became the first mayor of Sacramento and the first commanding general of the state's militia. He was a champion of temperance, and organized Sacramento's first Episcopal congregation. One of his granddaughters once wrote, "We are told that the general belonged to every fraternal society in Sacramento in the early days and it is quite probable that this is true." In his later years, living in San Francisco, Winn was troubled by the fact that, with each succeeding year, less and less heed was being paid to the "Days of '49," those robust hearty times when California became a state.

One way to solve the problem, he believed, would be to form an organization comprised of men who had been born in the state. His efforts to accomplish that did not meet with initial success. There was not an abundance of adult men living in the state in those days who had been born within its borders. In fact, head counts showed fewer than 300 residents of San Francisco would have then met the criteria.

In 1875, an advertisement was placed in the *Daily Alta* newspaper seeking to recruit "California boys" who would form a division in the forthcoming Independence Day parade in San Francisco. About 40 young men agreed to participate and on July 5 (the Fourth fell on a Sunday that year) they did indeed form a parade division. They escorted a decorated vehicle carrying children while they held the American and bear flags and a stuffed bear. Some of them wore miners' costumes to add color to the event.

A 20-year-old man who stood on Market Street beside Lotta's Fountain and watched the group pass by later wrote, "At that time I had just removed from Calaveras County and was fresh from the scenes of the early mining days. The feature of the parade to which I found special attention was the Ninth Division, composed entirely of young men born upon the soil of California. The Native Sons who marched on that occasion wore the rough miner's garb of pioneer days. They carried pick, pan and shovel upon their shoulders and at each man's side was strapped the ever-ready bowie knife and revolver. At their head was borne the bear flag of 1846. The appearance of the division was picturesque in the extreme; it left upon my mind a lasting impression." Apparently, it did. The writer of that passage, Richard C. Rust, eventually served as grand president of the Native Sons in 1900–1901 (and as superior court judge in Amador County, 1894–1908).

It was to be a busy summer for the young parade participants. In the weeks that followed, they formally organized the order, elected officers, and prepared for their participation in Admission Day observances. When Admission Day 1875 came, they marched from their hall on Bush Street to Woodward's Gardens at Fourteenth and Mission streets, once again carrying the state and national flags and the stuffed grizzly bear. At Woodward's Gardens, they enjoyed a picnic and dance. As evening came on, "literary exercises were held" and "orations" were delivered. An onlooker reported, "This observance was a credit to the infant order as well as a splendid tribute to the admission of California to the Union."

And so the tradition of Native Sons Admission Day parading was launched. In 1878, Gov. William Irwin proclaimed Admission Day a holiday and the process was repeated annually until 1888 when it became a statutory holiday. The preservation of California's glorious heritage is more than the preservation of physical landmarks and mementos, it is the preservation of the state's unique spirit. What better way to do that than join in a parade?

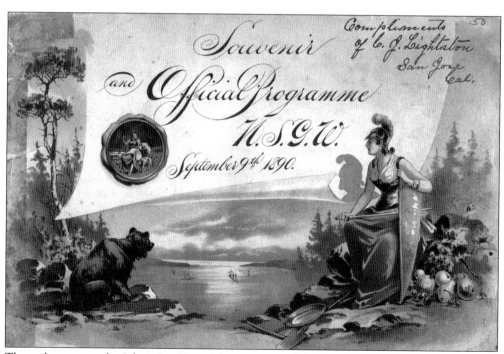

The early programs for Admission Day celebrations were elaborate works of art within themselves, such as this one announcing the festivities planned for 1890.

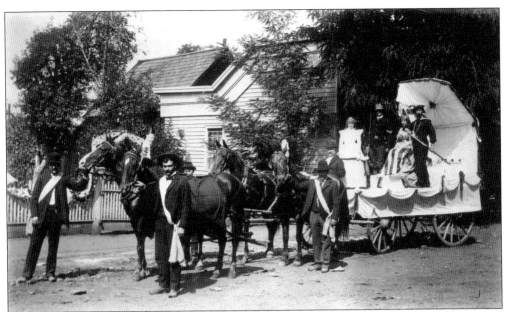

Admission Day celebrations also could be unpretentious and fairly effortless, like this decorated wagon at Weaverville in Trinity County in 1898.

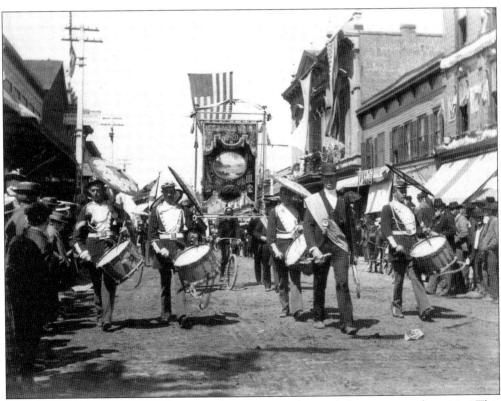

What's a good parade and celebration without music and a steady beat to rouse the spirits? This drum corps from Golden Gate Parlor 29 provided both for the 1888 Admission Day parade.

Admission Day ✳ ✳

✳ ✳ ✳ ✳ Celebration.

Santa Cruz Parlor No. 90.

N. S. G. W.

Santa Cruz, California

1888.

Santa Cruz Parlor 90 used this program with ornate type to announce its 1888 Admission Day celebration. Many wonder why local groupings of the Native Sons of the Golden West are called "parlors," rather than chapters or lodges. One common explanation is that the groups met in members' parlors, thus the name was adopted. This may be the case, although hard evidence suggests that whenever possible they met in some form of public assembly rooms, as it was better to get away from the cares of home and to engage in what future generations euphemistically would call "male bonding." Jo V. Snyder, writing a history of the order while he was its grand president in 1917, offered a much more matter-of-fact explanation for the name. "The designation of 'parlor' for each lodge was made in September 1875, the name being selected on account of being distinctive from other fraternities." There is no doubt about its distinctiveness, and readers are invited to accept whatever account of the name's origins strikes their fancy.

For those who wanted to hear more music after the parade passed by, two Native Sons parlors presented a concert at the 1888 festivities.

HEADQUARTERS

California Parlor, No. 1,

—«((AND))»—

Mission Parlor, No. 38,

→ N. S. G. W. ←

Santa Cruz, September 9, 1888.

CONCERT

AFTERNOON AND EVENING.

Second Regiment Band.

Ornate arches were a feature of parades in the Victorian era. This one was erected on Sacramento's K Street at Fourth Street (looking west) for the 1895 Admission Day parade.

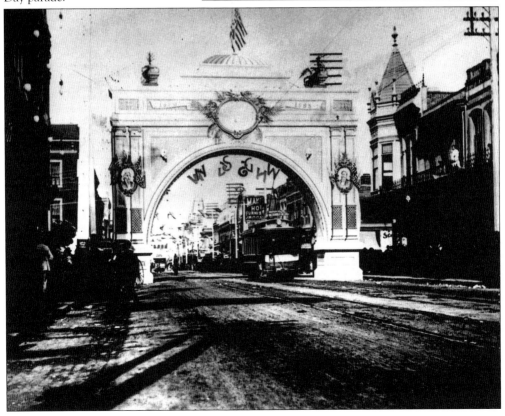

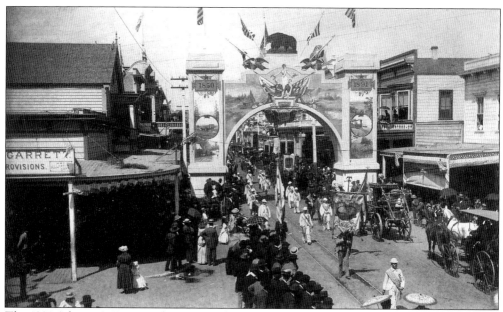

The 1891 Admission Day parade passes under the ornamented arch Santa Cruz provided for that year's celebration.

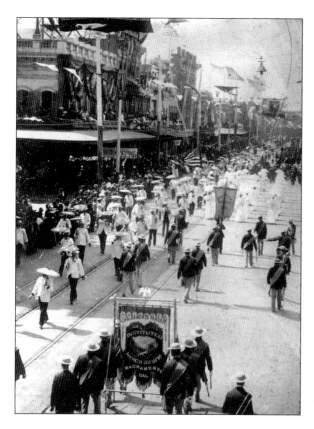

Members of Sacramento Parlor 3 carry their banner in the 1895 Admission Day parade.

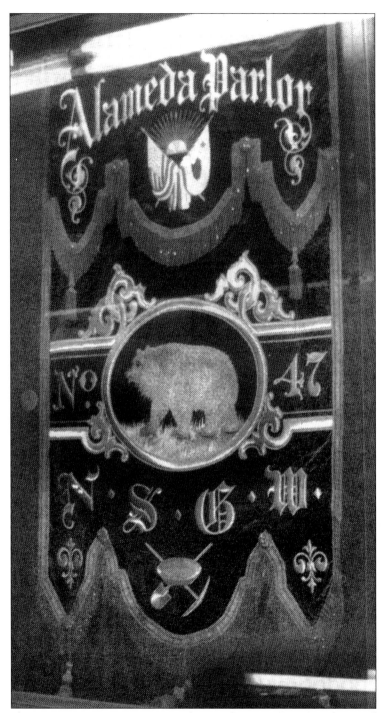

At one time, banner-carrying was an essential part of Native Sons parading and celebrating. Elaborate banners were designed to identify parlors and officers. Unfortunately, black-and-white photography cannot begin to do justice to the embroidery and craftsmanship (often including hand-painting) that adorned those banners. This one, belonging to Alameda Parlor 47, is typical of the styles represented.

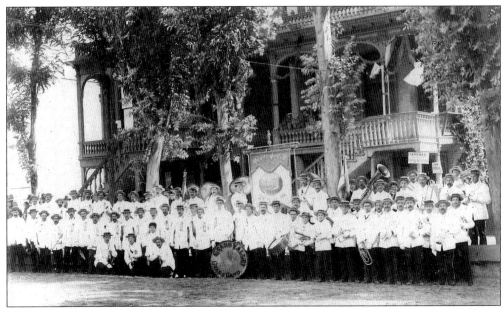

Having made the trip from Grass Valley, members of Quartz Parlor 58's large band assemble for the 1895 parade.

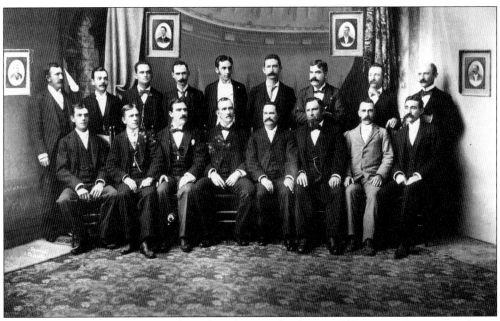

While the celebrations might have been fun, planning for them could be serious business, as shown by the solemn, resolute expressions on the faces of members of this 1896 planning committee from Stockton.

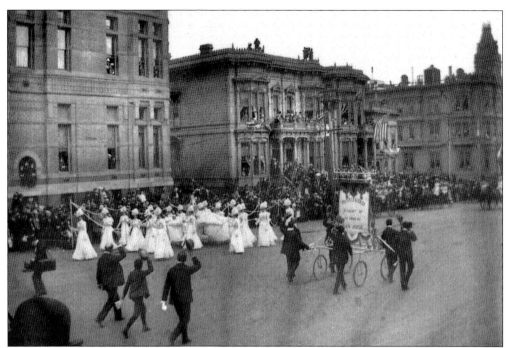

The customs of the day are reflected as these Native Sons from San Jose, marching in an Admission Day parade probably in the late 1890s, tip their hats to lady participants. Notice the wheeled device that made it an easy task for them to carry their banner. (This photo is part of a collection that the Historical Preservation Foundation of the Native Sons, purchased in 2004 to supplement the organization's photographic archives.).

In 1900, the 50th anniversary of California's statehood rated a four-day celebration, as evidenced by this invitation.

The honor of your presence is requested

by the

Native Sons of the Golden West,

in

San Francisco, California,

September the eighth, ninth, tenth and eleventh,

nineteen hundred,

on the occasion of the celebration of the

Fiftieth Anniversary of the Admission

of California into the Union.

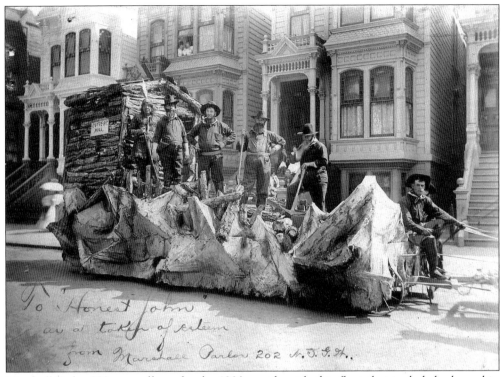

Marshall Parlor 202 went all out for the 1900 parade with this float that included a log cabin and members in miners' garb.

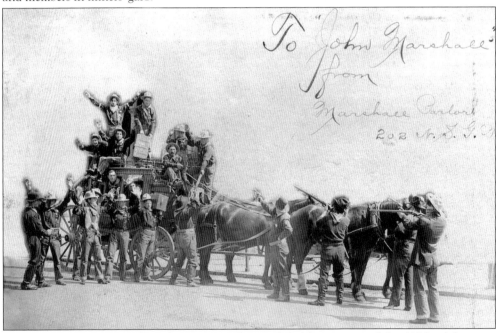

Some members of Marshall Parlor 202 staged a mock holdup as part of the 1900 celebration. (Despite the inscription, the photo could not have been a gift to the parlor's namesake, the discoverer of gold. The discoverer, James Marshall, had died in 1885.)

Centuries may pass, but Native Sons still like to dress up in garb of the Old West. This contingent added a touch of spirit and style to an event in 2003. (Do you suppose they served much espresso and gelato in the mining camps of 1849?)

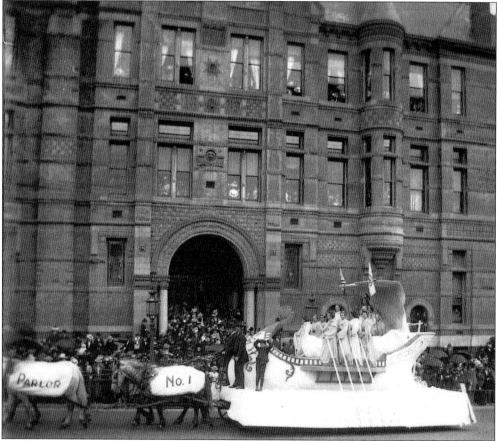

Where does the name "California" come from? No one knows for certain, but it is believed to have been derived from a 16th-century romantic novel about an earthly paradise, *Las Sergas de Esplandian*, by Garcia Ordonez de Montalvo, a literary work Spanish explorers likely would have been familiar with. Here California Parlor 1 seeks to recreate that paradise through its entry in the 1900 Admission Day parade.

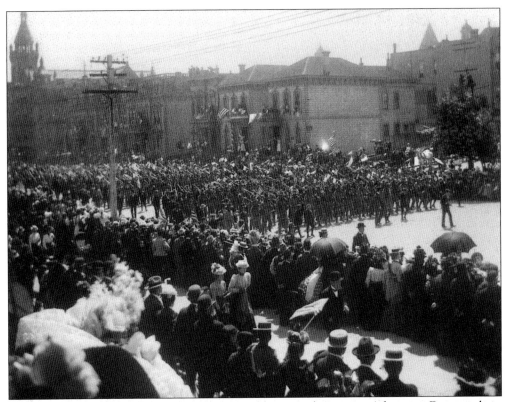

These are supposedly Spanish-American War soldiers marching in an Admission Day parade in San Francisco. But when? The photograph is among a group supposedly of the 1900 parade, but the image was made with the cumbersome Daguerreotype process that was going out of style by the turn of the century. Also, the peace protocols ending the Spanish-American War were signed August 12, 1898. Could it be that these are newly returned veterans marching in the 1898 Admission Day parade?

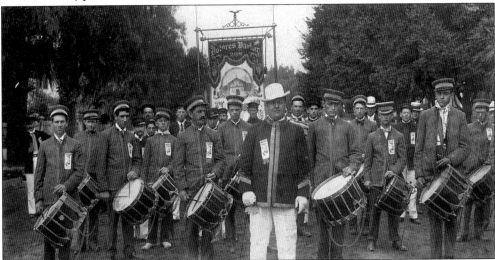

Members of the Dolores Parlor 208 drum corps parade are in San Jose for the 1907 Admission Day celebration.

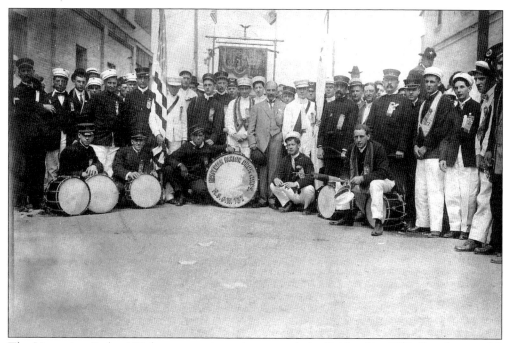

The Hesperian Parlor 137 drum corps is ready to parade in Oakland in 1913. Standing in the gray suit at the right of the bass drum was one of the parlor's more prominent members, James Rolph Jr., then mayor of San Francisco and later governor of California.

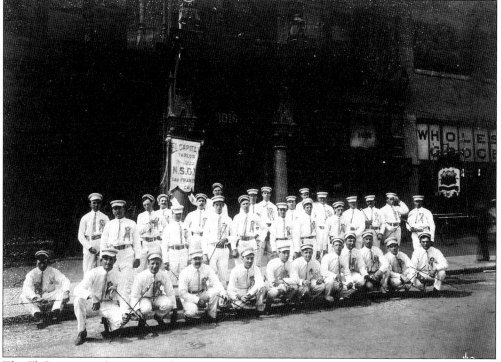

The El Capitan Parlor 222 marching unit is ready with its walking sticks for Oakland's parade in 1913.

The program for Sacramento's 1926 Admission Day celebration listed an extensive series of events.

ADMISSION DAY CELEBRATION

Program of Events

WEDNESDAY, SEPTEMBER 8TH.

8:00 P. M. to 11:00 P. M.—Committee with band and drum corps meeting special trains.

9:00 P. M.—Dancing and reception at Native Sons Hall, 11th and J Streets under auspices Sacramento County Parlors, N. S. G. W.

THURSDAY, SEPTEMBER 9TH.

9:30 A. M.—Marking of the first Wells Fargo Express Company Office on the Southwest corner of Second and J Streets, by the Grand Officers of the N. S. G. W., and Officials of the Wells Fargo Bank and Union Trust Company of San Francisco. Speakers, C. W. Banta, Vice-President Wells Fargo Bank and Union Trust Company, Casper P. Hare, Past President.

10:30 A. M.—Historical Parade. Participants will form on Front Street between I and M Streets. Line of march starting at 2nd and J, east on J to 16th, south on 16th to K west on K to 4th, south on 4th to L, east on L to 15th, countermarch on L passing the reviewing stand, disbanding on 6th.

12:30 P. M.—(Or immediately after Parade)—Literary Exercises Memorial Grove, State Capitol Grounds. Music by the band. Remarks by Judge J. F. Pullen, chairman. Address, Grand President Hillard F. Welch. Oration, Past Grand President, Judge Fletcher Cutler. Music by the band.

2:00 P. M.—Visit to Sutter Fort, 28th and L Streets. Band concert Sutter Fort Grounds Piedmont Parlor Band N. S. G. W.

2:00 P. M.—Exhibition swimming and contests at Joyland Park.

2:30 P. M.—California State Fair Grounds: N. S. G. W. Drum Corps contest and N. D. G. W. Drill Team contest.

5:00 P. M.—Presentation of the American Flag and the Bear Flag to the State Agricultural Society from the Admission Day General Committee of the N. S. G. W. Presentation by Grand President Hillard E. Welch. Acceptance by President, State Agricultural Society, Robert A. Condee.

8:00 P. M.—Fireworks at the California State Fair Grounds. Open House by the various parlors.

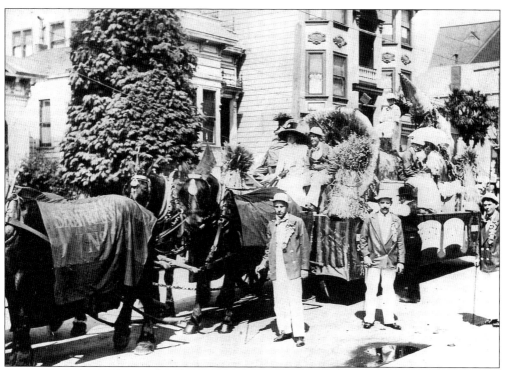

Carquinez Parlor 205 has its float hitched up and ready to go for Vallejo's 1914 parade.

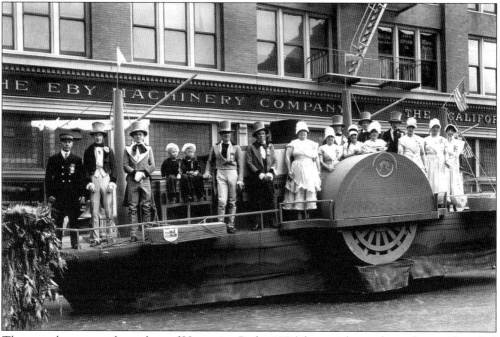

The smartly costumed members of Hesperian Parlor 137 (along with members of an unidentified Native Daughters' parlor) stand on the deck of their float for the 1923 Admission Day parade. The replica of the of the ship *Oregon*, which brought news of California statehood in 1850, made appearances in several mid-1920s parades.

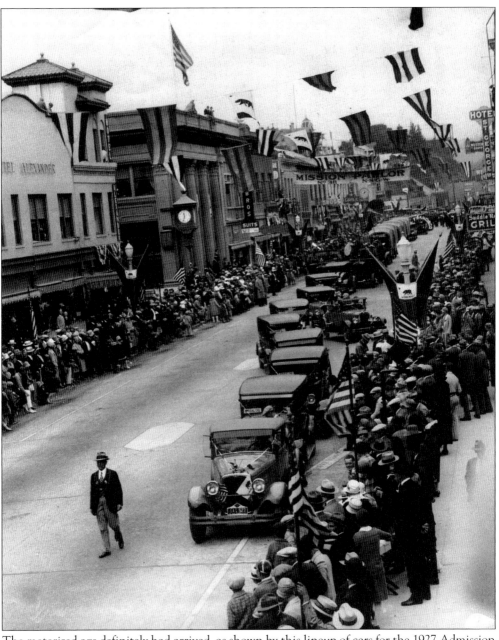

The motorized age definitely had arrived, as shown by this lineup of cars for the 1927 Admission Day parade in Santa Cruz.

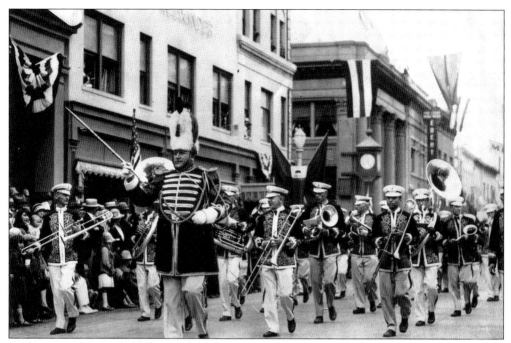

Piedmont Parlor 120 fielded a good-sized marching band for the 1927 parade in Santa Cruz.

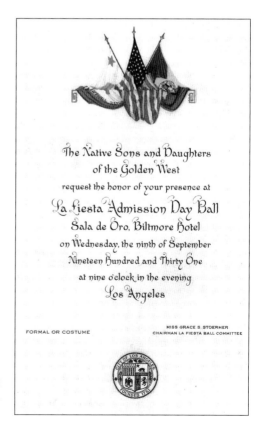

The Native Sons and Daughters
of the Golden West

request the honor of your presence at

La Fiesta Admission Day Ball
Sala de Oro, Biltmore Hotel

on Wednesday, the ninth of September
Nineteen Hundred and Thirty One
at nine o'clock in the evening
Los Angeles

FORMAL OR COSTUME

MISS GRACE S. STOERMER
CHAIRMAN LA FIESTA BALL COMMITTEE

Los Angeles's Biltmore Hotel, then the classiest place in town, was the venue for an Admission Day ball in 1931.

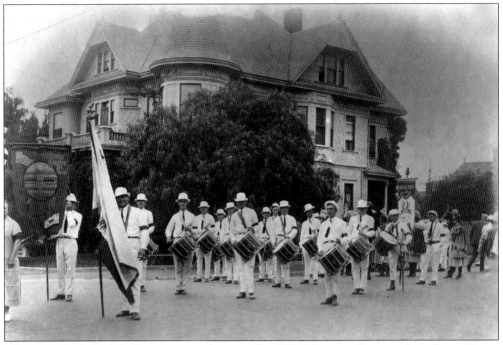

The Fruitvale Parlor 252 drum corps performs in the 1929 Admission Day parade in Santa Cruz.

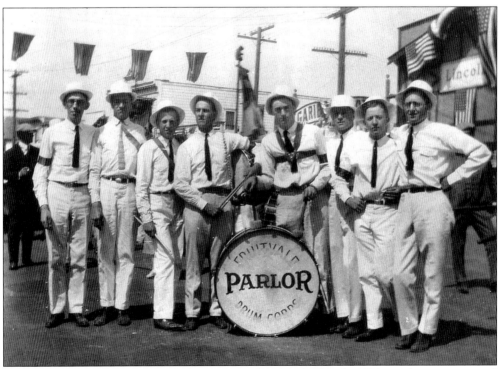

Members of the Fruitvale Parlor 252 drum corps take a break after the 1929 parade to pose around one of their drums.

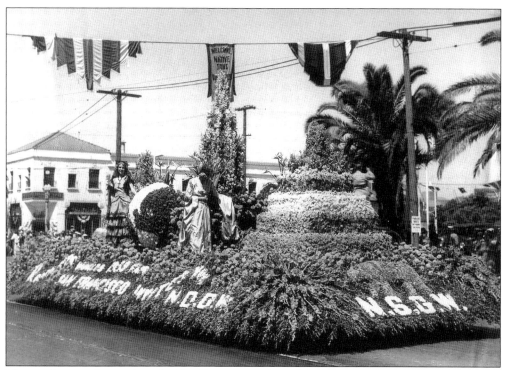

The north visits the south as the San Francisco parlors of the Native Sons and Native Daughters pitched in together to enter a float in Santa Monica's 1939 Admission Day parade.

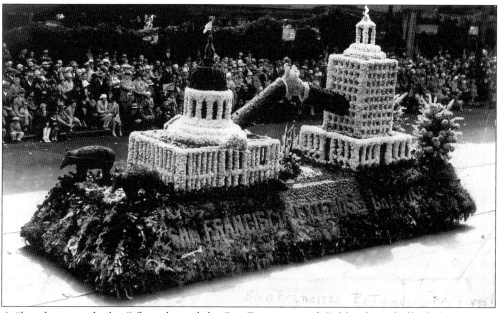

A "hands across the bay" float showed the San Francisco and Oakland city halls shaking hands in 1936 Admission Day parade in Oakland.

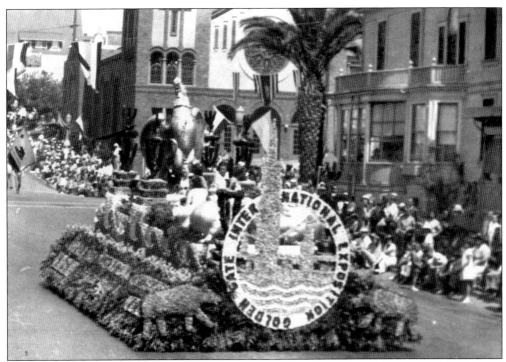

A San Francisco entry in the Admission Day parade in Vallejo in 1938 promoted the World's Fair that would open five months later on Treasure Island.

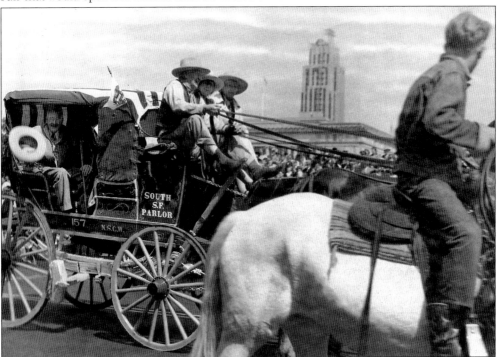

South San Francisco Parlor 157's stage coach, driven by Charley Gaines in the 1946 Admission Day parade in San Francisco, was a popular feature of many parades.

California's centennial of statehood was marked by a cavalcade of events in San Francisco that included displays of electrical lighting, church services, folk dancing, fireworks, a festival, and of course a parade. In Sacramento, the centennial theme dominated the state fair. With the wide variety of events offered, however, the parade, while impressive, was not the major-league, focal point presentation that it had been 25 years earlier when the state celebrated its Diamond Jubilee.

CALIFORNIA CENTENNIALS COMMISSION
SAN FRANCISCO CENTENNIAL COMMITTEE INC.
CALIFORNIA STATEHOOD CENTENNIAL
SEPT. 2-9. 1950 SAN FRANCISCO
A CAVALCADE

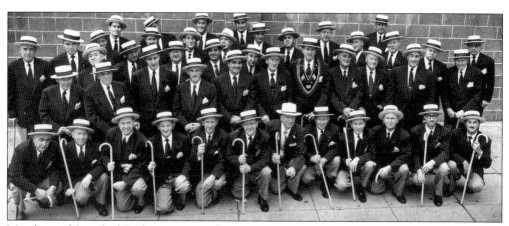

Members of Stanford Parlor 76 are ready to parade in 1950 with their canes, straw hats, and matching blazers.

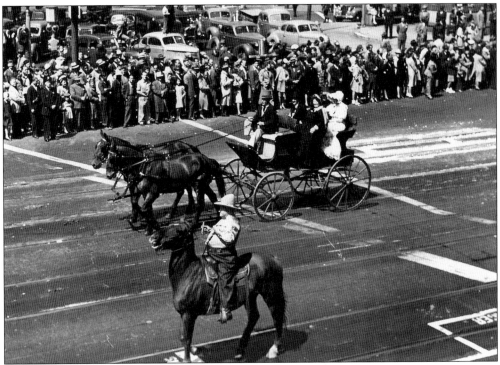

The grand marshals of the Native Sons and Native Daughters were carried by buggy in the 1950 centennial parade.

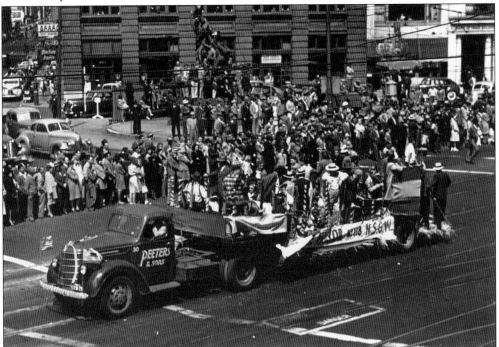

Members of National Parlor 118 crowd on to a bunting-festooned flatbed truck for the centennial parade.

Philip Martinelli, a member of the Junior Native Sons from Sacramento, leads a burro in Stockton's 1953 Admission Day parade.

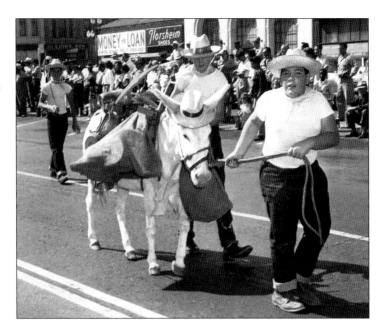

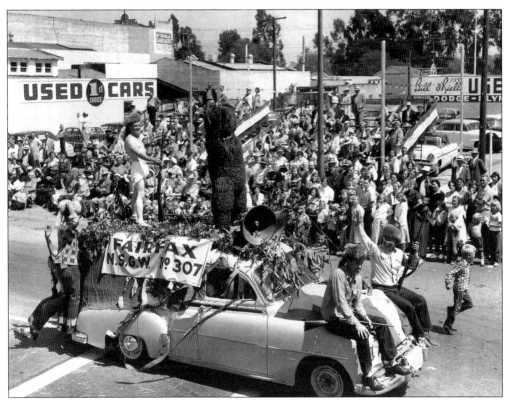

Pictured here is Fairfax Parlor 307's entry in the Santa Cruz Admission Day parade in 1955. The member atop the car is wearing a diaper (with his coonskin cap) because Fairfax was a "baby parlor," having just received its charter that year.

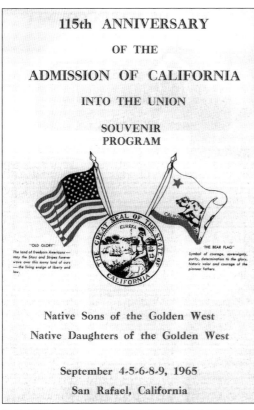

115th ANNIVERSARY

OF THE

ADMISSION OF CALIFORNIA

INTO THE UNION

SOUVENIR
PROGRAM

"OLD GLORY"
The land of freeborn Americans — may the Stars and Stripes forever wave over this sunny land of ours — the living ensign of liberty and law.

"THE BEAR FLAG"
Symbol of courage, sovereignty, purity, determination to the glory, historic valor and courage of the pioneer fathers.

Native Sons of the Golden West
Native Daughters of the Golden West

September 4-5-6-8-9, 1965
San Rafael, California

Even though it was not a "major year" anniversary, San Rafael hosted an extensive five-day celebration of Admission Day in 1965.

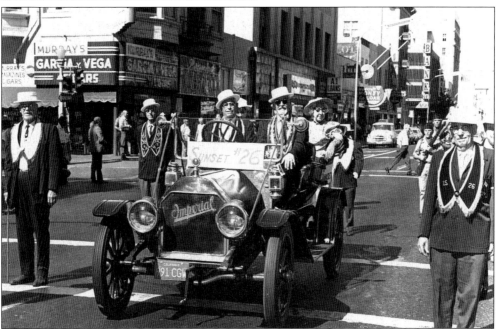

Once upon a time, automobiles like this one would have been the standard mode of conveyance in Admission Day parades, but by 1971, when this one appeared in the Sacramento parade, they had become curiosities.

In 1976, America's bicentennial year, Rudy Castillo (right), a past president of Santa Barbara Parlor 116, was el presidente of Santa Barbara's Old Spanish Days annual celebration. He commissioned parlor member Jesse Garcia (left) to create a theme poster for the fiesta. Garcia's poster tied two events of 1776 together: Juan Bautista de Anza's explorations on the West Coast and the East Coast's Liberty Bell (21 years later, Garcia would become grand president of the Native Sons.)

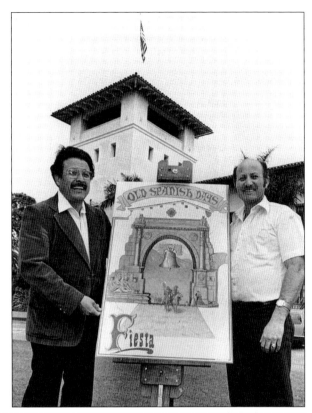

Chip Wullbrandt (below right), a member of Santa Barbara Parlor 116, served as el presidente of Santa Barbara's Old Spanish Days in 2005. Here he welcomes a group of Native Sons visitors in the courtyard of Santa Barbara Mission, including Grand President Tom Sears (back row, center).

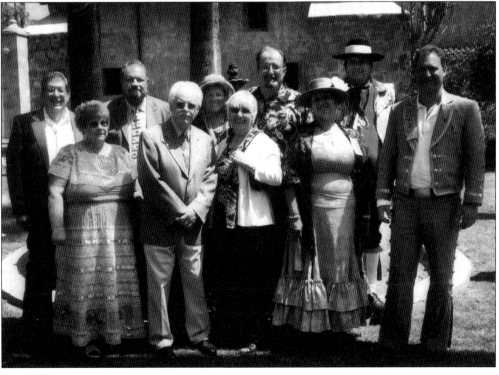

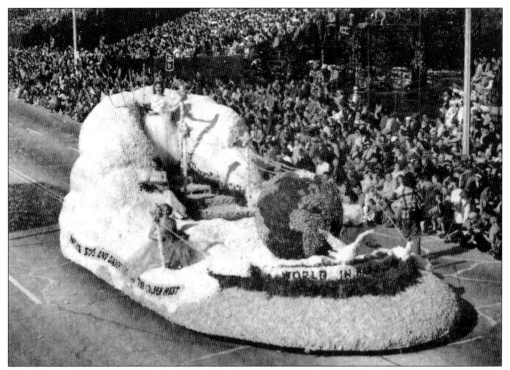

California's most famous parade, even though it has nothing to do with Admission Day, is the Tournament of Roses parade held on New Years Day in Pasadena. From the post–World War II era until the 1980s, the Native Sons and Native Daughters jointly participated in it on an annual basis. This 1952 "World in Harmony" float contained 280,000 blooms.

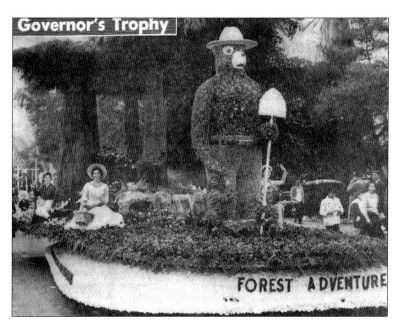

The 1959 Native Sons/ Native Daughters Rose Parade entry, "Forest Adventures," won the Governor's Trophy.

Two

THE MOTHER OF
ALL PARADES

The Roaring Twenties were a time of immense optimism and belief in progress. So it should come as no surprise that California's Diamond Jubilee in 1925, marking the 75th anniversary of statehood, was an unusually spectacular event. The weeklong pageant in San Francisco was marked by lighting, decorations, speakers, a grand ball, a San Francisco–Honolulu airplane flight, a fashion show, competitive drills, automobile races, and of course a parade.

Actually, it might aptly be called "the mother of all parades." An estimated 55,000 people took part as it reached a length of 17 miles. It required 5 hours and 15 minutes for it to pass by the official reviewing stand. It included nearly 300 floats (102 of them depicting historical events), members of 182 organizations marching in line, and 62 vehicles carrying dignitaries. It is said that it "left no important incident (of California's history) unpictured."

The Native Sons of the Golden West served as a major co-sponsor of the jubilee (along with the Society of California Pioneers and the Native Daughters of the Golden West), and when parade day came they provided several thousand marchers, drum corps players, and band members in virtually all divisions of the giant parade.

The floats entered by the Native Sons parlors included "Discovery of Pacific by Balboa" by Balboa Parlor 234; "Discovery of California by Sir Francis Drake" by Castro Parlor 232; "San Carlos, First Vessel to Enter San Francisco Bay Through Golden Gate" by Golden Gate Parlor 29; "Anza's Expedition, Founding of San Francisco" by James Lick Parlor 242; "Mission San Diego" by Twin Peaks Parlor 214; "Mission San Francisco de Assisi" by Dolores Parlor 208; "Mission Santa Barbara" by Santa Barbara Parlor 116; Mission San Francisco Solano by Sonoma Parlor 111; "Presidio of San Francisco, Commandant Headquarters" by Presidio Parlor 194; "Founding of Fort Ross by Russians" by Santa Rosa Parlor 28; "Baptism of Chief Marin" by Tamalpais Parlor

64; "First American Pioneer Party, Captain Jed Smith" by El Capitan Parlor 222; "Planning of Yerba Buena by Alcalde Parlor 154; "Bear Flag Republic" by Berkeley Parlor 210; "Monument to Donner Party" by Byron Parlor 170; "American Flag Raised on Portsmouth Square," by San Francisco Parlor 49; "Discovery of Gold by Marshall" by Marshall Parlor 202; "Great Seal of the State of California" by Stockton Parlor 7; "Legend of Mount Diablo" by Bret Harte Parlor 260; "Arrival of S.S. *Oregon* with News of Admission of California," by Hesperian Parlor 117; "Driving Last Spike" by Palo Alto Parlor 216; "Pioneer Gate at Menlo" by Menlo Park Parlor 185; "Jubilee Diamond" by Stanford Parlor 76; and "Father Ricard's Work for Science" by Santa Clara Parlor 100. Floats presented by Carquinez Parlor 205 and Diamond Parlor 246 featured industrial themes. Accompanied by stagecoaches, Native Sons from Auburn Parlor 59 (much as they do today), Rocklin Parlor 233, Marysville Parlor 6, Rainbow Parlor 40, and Sutter Parlor 261 formed a "miners' group." It was reported:

> At the time of the establishment of headquarters by the executive committee, authorities on the matter of costumes worn during the Spanish era in California, and artists of international celebrity were added to the advisory staff. Every parlor was furnished with data provided by the costuming experts.
>
> Cooperation between those who designed historical floats and the technical staff of the Jubilee Committee was at all times cordial. Every day members of the committee would visit the building and yards in which the work was going on, giving helpful suggestions and aiding in every possible way to make the depictions authentic and suitably appealing.

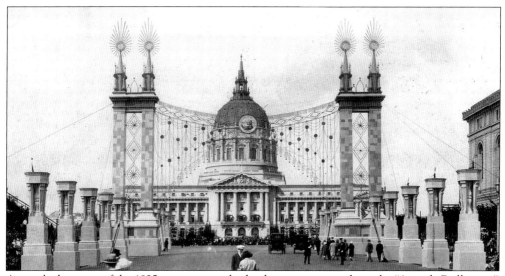

A parade the scope of the 1925 extravaganza had to have a proper arch, so the "Arco de Brilliantes" was erected in front of San Francisco City Hall.

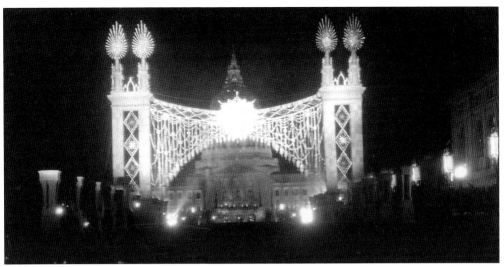

Illuminated at night, "Arco de Brilliantes" lived up to its name.

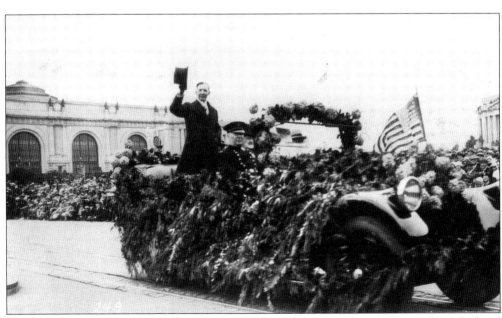

Vice President Charles Gates Dawes was the jubilee's most honored guest and rode at the head of the parade in this car festooned with garlands.

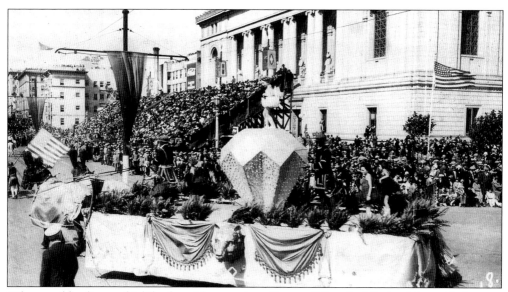

What would a diamond jubilee be without a giant diamond? Stanford Parlor 76 provided one.

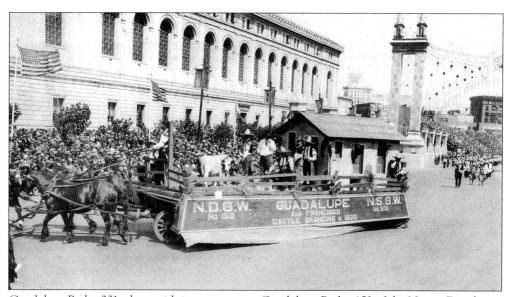

Guadalupe Parlor 231, along with its counterpart Guadalupe Parlor 153 of the Native Daughters, presented a float showing life during California's Spanish period.

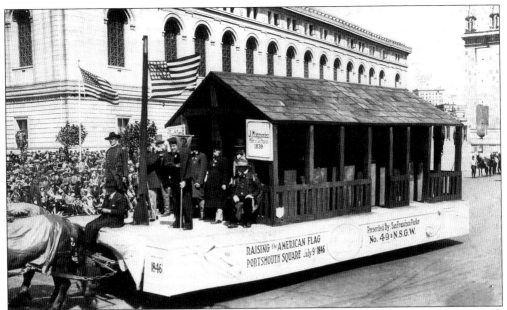

San Francisco Parlor 49 recreated the raising of the American flag at San Francisco's Portsmouth Square by Naval Capt. John B. Montgomery on July 9, 1846, two days after Commo. John Drake Sloat raised it over California's capital (at the time) of Monterey. The square was named after the ship Montgomery commanded.

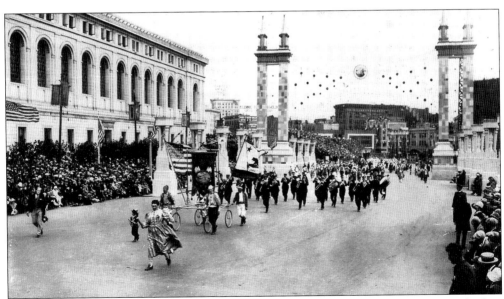

Golden Gate Parlor 29 provided one of the many Native Sons drum corps that were in the line of march.

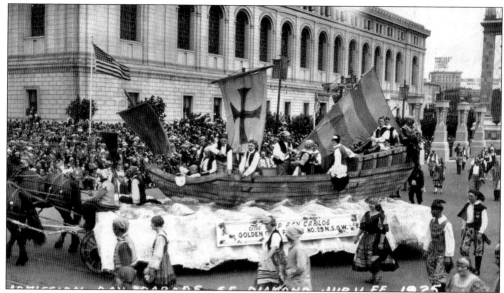

Golden Gate Parlor 29 presented a float showing a replica of the *San Carlos*, the first Spanish vessel to enter San Francisco Bay in 1760 as part of Gaspar de Portola's expedition.

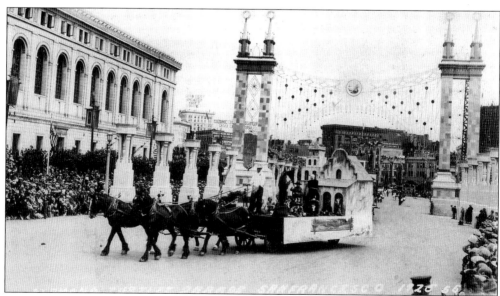

Twin Peaks Parlor 214's float showed San Diego Mission, the first of the missions founded in 1774. (Twin Peaks is based in San Francisco; apparently San Diego Parlor had been assigned another task.)

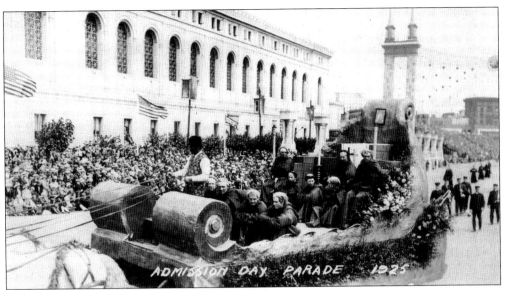

San Mateo Parlor 23 showed mission founder Fr. Junipero Serra "ending his earthly labors."

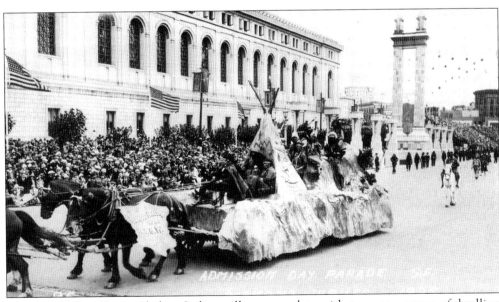

Redwood Parlor 66 provided an Indian village, complete with teepees—a type of dwelling California Indians did not build.

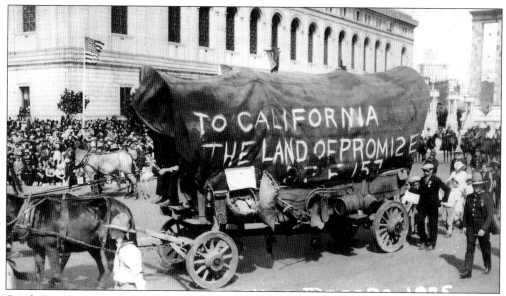

South San Francisco Parlor 157 added color to the parade with its covered wagon.

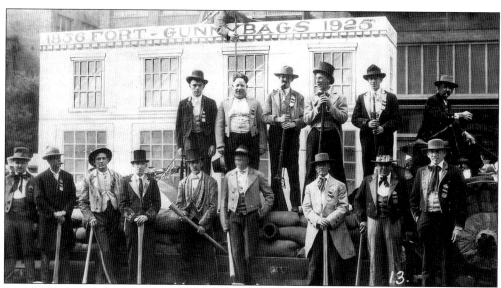

Mission Parlor 38 provided parade viewers with some exceptionally well-dressed gentlemen representing members of the vigilance committees that were active in San Francisco in 1851 and 1856 when law and order left something to be desired.

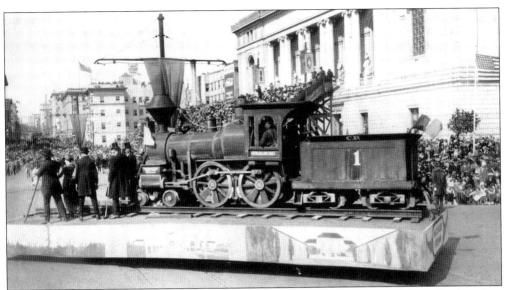

Palo Alto Parlor 216's float illustrated driving the last spike in the transcontinental railroad on May 10, 1869, thus linking the Central Pacific Railroad, whose lines began at Sacramento, with the East Coast.

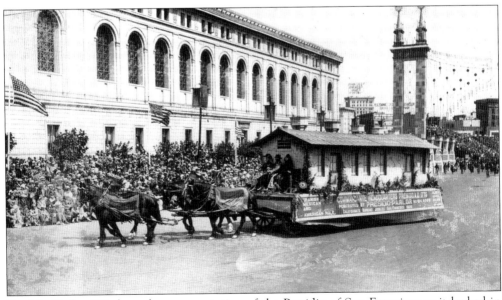

Presidio Parlor 194 showed a representation of the Presidio of San Francisco as it looked in its infancy.

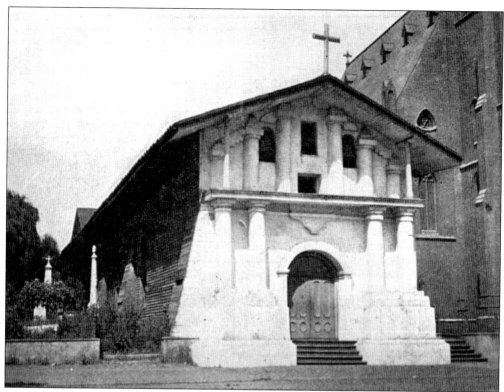

This photograph of Mission Dolores, taken around the same period, shows how faithfully the float makers worked to re-create the structure's appearance. (In June 2001, the Native Sons placed a plaque in the mission's garden, commemorating the 225th anniversary of its establishment.)

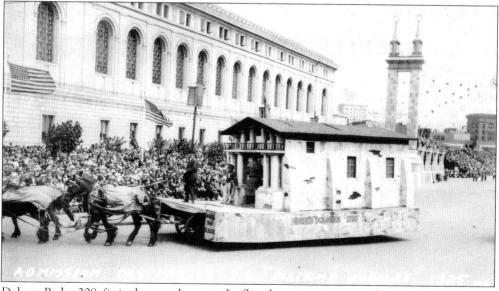

Dolores Parlor 208, fittingly enough, created a float honoring its namesake, Mission Dolores.

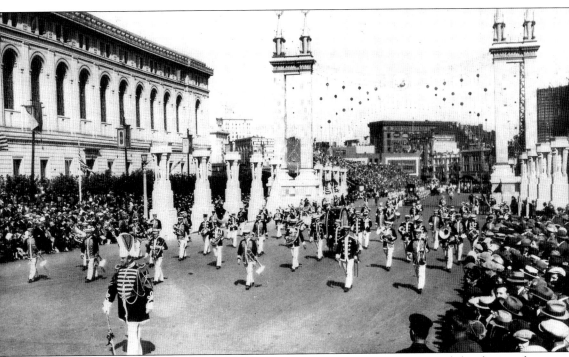

Here one of the many Native Sons bands that provided music for the massive parade heads toward the reviewing stand.

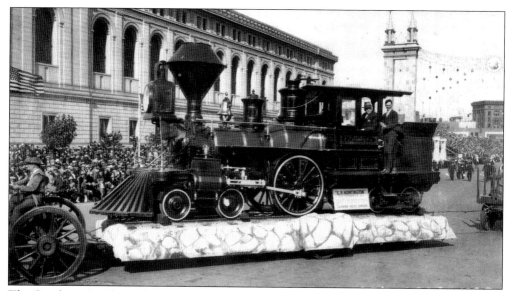

The Southern Pacific Railroad provided the engine *Collis P. Huntington* for the parade. The engine would make an encore performance at California's sesquicentennial celebration in 2000, courtesy of the California Railroad Museum.

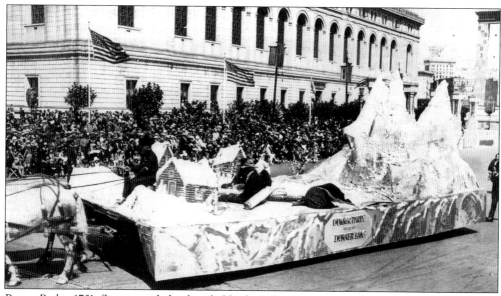

Byron Parlor 170's float provided a detailed look at the Donner Party, the pioneers who became trapped in the snows of the Sierra in the winter of 1846–1847. Of the 87 men, women, and children involved in the ordeal, 40 perished.

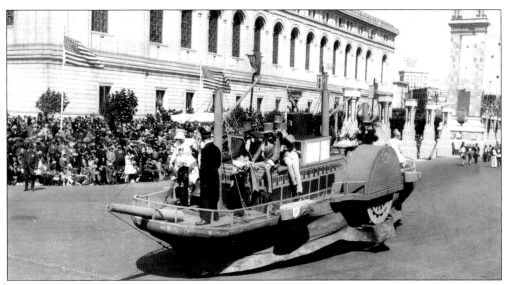

Members of Hesperian Parlor 137 rode in the bow of their version of the ship *Oregon*, which brought the first news of statehood to California in 1860.

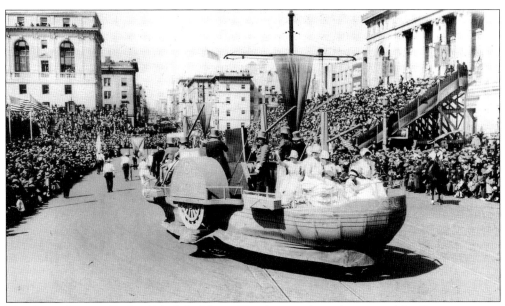

Members of Dorina Parlor 144 of the Native Daughters rode in the stern of the *Oregon*.

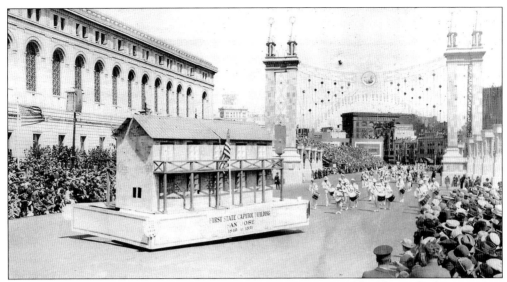

San Jose Parlor 22, presented a likeness of California's first capitol building, which was at San Jose. The actual building, with a single room on the upper floor, and four rooms on the ground floor, was destroyed by fire April 29, 1853.

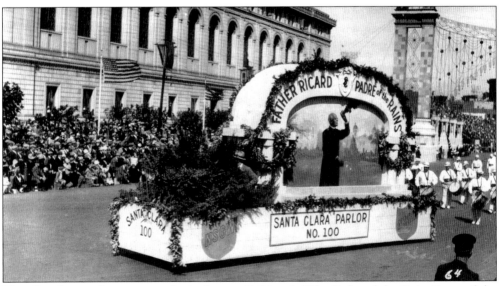

This float honors Jesuit meteorologist Jerome S. Ricard, "The Padre of the Rains," one of the best-known faculty members of Santa Clara University in 1920s. He had astonishing success at predicting weather by the actions of sunspots.

Three

RESTORING
AND PRESERVING

To celebrate California's statehood properly, it helps to know something of its history. Many of the state's landmarks that remain as fundamental images of its colorful past are here today because of the efforts of the Native Sons of the Golden West to preserve them down through the years. This book is not intended to be a comprehensive story of Native Sons preservation efforts, but an overview of the organization's more significant accomplishments that include: purchasing the remaining ruins of Sutter's Fort in Sacramento and deeding them to the state; providing the site for the marshall of the "Discovery of Gold" Monument at Coloma; assisting in the restoration of Colton Hall in Monterey, where California's first state constitutional convention was held; advocating and assisting in the restoration of the Custom House at Monterey, the oldest public building in the state; aiding in securing legislation in which the largest redwood forest in Big Basin became the property of the state, thus forming the nucleus for the state park system; securing state appropriations for restoration of the Spanish mission at Sonoma (1 of 2 among the 21 missions—the other being La Purisima near Lompoc in Santa Barbara County—that are state parks); acquiring and preserving the Vallejo adobe at Petaluma; erecting a monument to the unfortunate pioneers who lost their lives at Donner Lake; working and providing funds for the restoration of the Franciscan missions of California's Spanish era.

When Santa Ynez Mission's distinctive bell tower was leveled in a storm in 1911, the Native Sons came forward with $900 to rebuild the tower, a donation lauded by Bishop Thomas J. Conaty as the only one from a source outside the Roman Catholic Church to help rebuild the tower. Over the years, the Native Sons' donations to the missions have not been mammoth, but they have been well placed and come at key times crucial to the missions' preservation. It was the Native Sons' impetus, for example, which kicked off the campaign to save San Diego Mission, one that finally saw success in 1931.

The organization also has placed markers at hundreds of sites of historic interest throughout the state. Two museums maintained by the Native Sons offer visitors an admission-free glimpse at the past. The story of the preservation of Sutter's Fort is uniquely interesting because it illustrates how the histories of the state and of the organization intertwine. During the Native Sons' Grand Parlor of 1888 in Fresno, C. E. Grunsky of Sunset Parlor 26 offered a resolution that read:

> There is no spot in California more intimately associated with the history of the pioneer days of this state than Sutter's Fort. It commends the veneration of all Native Sons of California, and it is the duty of our organization to perpetuate the memories associated with the spot and to preserve the site of the fort from further desecration; therefore be it resolved, that a committee of five be appointed by the grand president to devise ways and means for the restoration of Sutter's Fort and its permanent preservation.

The motion was adopted and referred to the incoming grand president, M. A. Dorn, who appointed Grunsky, W. M. Sims, and Frank D. Ryan (who was grand first vice president, and would be grand president in 1889–1890) to the committee. Curiously enough, although the resolution called for a five-member committee, for reasons now lost to time, its actual membership never rose above those three persons during its entire existence.

In 1889, Grunsky submitted a report to Grand Parlor saying that the Sutter's Fort committee's work had hit a roadblock. Before any restoration work could be done, he explained that the fort site had to be purchased and the committee had thus far been unsuccessful in getting its owners to name a price. To prevent the owner from "making an exorbitant demand when he learns for what purpose the property is desired," the committee recommended that "no mention of proceedings had in this Grand Parlor with reference [to Sutter's Fort] be made in the newspaper reports." In other words, they were keeping a low profile in hopes of keeping the price down. A motion was created by A. Ruef, which was adopted. (In the future, Ruef, the political boss of San Francisco, was to spend less happy times; in the post-earthquake reform movement, he was convicted of accepting bribes and sent to San Quentin Prison.)

Evidently, some time during the following year a price was determined because the Grand Parlor of 1890 instructed Grunsky's committee to purchase the property, offer it to the state, and "to ask the Legislature to make suitable appropriations for the maintenance of the property and such restoration of the old fort as might seem advisable." By the following Grand Parlor, the committee was able to report triumphantly that "these instructions have been fully and successfully carried out."

In its final report to the Grand Parlor in 1891, the committee announced that the purchase and donation of the property by the Native Sons had been accomplished, and that the state legislature had acted as requested. A "matching funds" deal had been struck. The Native Sons paid $20,000 to buy the fort; in return for getting title to the fort property, the state would spend $20,000 to restore it. A statute signed by Governor Markham on March 7, 1891, accepted the fort "without cost to the state" from the Native Sons, and had appropriated $20,000 (half to be spent in 1891 and the other in 1892) for its restoration and upkeep.

A treasurer's report by the Native Sons' committee showed that the organization paid $20,000 to B. Merrill, W. P. Coleman & Company for the fort. Merrill, a resident of the Midwest, was the "absentee landlord" who owned the bulk of the property. The largest donor to the fund was "Col. C.F. Crocker, elsewhere described as "a prominent Native Son," who provided $15,000, or three-fourths of the total amount the order raised. Crocker (who liked to be addressed by his state militia title, but was known to his friends as "Fred"), the eldest son of Charles Crocker of the Big Four transcontinental railway builders, was president of the Southern Pacific Railroad.

Evidently, Grunsky's negotiations with the sellers of the land went exceptionally well because the next most generous donor turned out to be none other than B. Merrill, who gave $2,000. Considering that all this took place many decades before the advent of income taxes—and charitable deductions—it was an extremely generous rebate from the former owner.

Sen. Leland Stanford, a surviving member of the Big Four (but a native of New York state who could not join the Native Sons), gave $400. His wife, Jane Lathrop Stanford, proved more generous by giving $500. Sacramento Parlor 3 likewise donated $500, and the Native Sons held a fundraising ball that generated $194.55. Other parlors that donated were Najoqui, $10; Golden Fleece, $30; Redwood, $25; Stockton, $50; Benicia, $9; Gablian, $26; Silver Star, $31; Plymouth, $20; San Diego, $25; Arrowhead, $24; Napa, $50; Lassen, $25; Highland, $17; Palo Alto, $20; Willows, $50; and Santa Lucia, $15.75. As an order, the Native Daughters gave nothing, but several of that order's parlors did: Laurel, $11.60; Manzanita, $10.50; Ursula, $10; Dixon, $20; and Mizpah, $10. A number of Sacramento businesses contributed, including the department stores Weinstock, Lubin & Company and Hale Bros. & Company, each giving $100; the Sacramento Society of Pioneers gave $90; the New England Society of Pioneers in Boston offered $100; and the New York Pioneers contributed $50.

For Grunsky, who was a civil engineer, Sutter's Fort would become a lasting avocation. Documents in the fort's archives show that, as the state went about constructing the replica walls you see today, he played a significant role in overseeing the process. A guardian, paid $750 annually, and a gardener, paid $1,000 annually, were appointed to care for the fort; both were Republicans. (The patronage system was pervasive in those days.)

In 1907, the legislature appropriated $8,000 "for the purpose of providing more suitable boundaries" for the park. Because of that purchase, L Street bows out to the south, instead of running immediately in front of the fort's entrance. Later, through the efforts of Harry C. Peterson, who served as the fort's curator in the late 1920s and throughout the 1930s, the fort was transformed from an empty shell of buildings into a museum. He was primarily responsible for assembling the collection of pioneer relics that continue to form the core of the fort's displays.

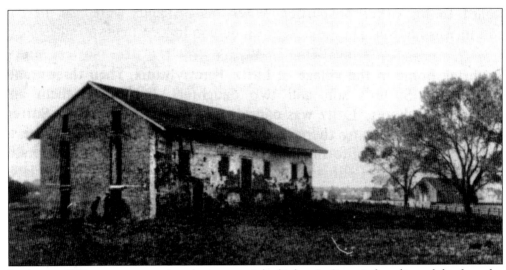

In August 1939, to commemorate the centennial of John A. Sutter's founding of the fort, the Historic Landmarks Committee of the Native Sons placed a plaque at the fort that reads in part, "Fort restored as result of movement inaugurated by Native Sons of the Golden West, the funds being originally provided by the order, the state of California and individuals." In 1888, not much remained of the once-extensive buildings of Sutter's Fort when the Native Sons began their successful campaign to save it. The effort came at the critical moment. As a result, visitors today can experience a setting much like the one that greeted pioneers who arrived in California in the 1840s.

The discovery of gold in 1848 brought little joy to James W. Marshall. Embittered in his later years, he felt that history had passed him by. Placerville Parlor 9 was among the few groups that made an effort to acknowledge his contribution to history. This photographic portrait, said to be the last made before Marshall's death in 1885, has been accorded an honored place among the parlor's mementos for decades.

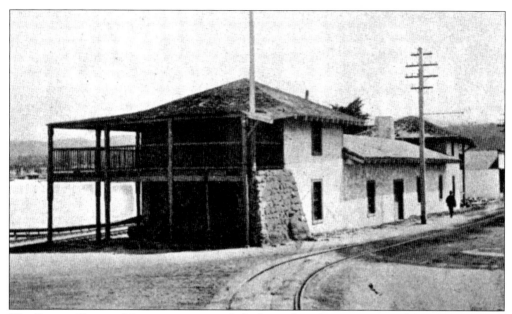

The Custom House at Monterey, portions of which may have been constructed during California's Spanish period, making it the oldest public building in California, is shown here before restoration. In 1900, in a movement begun by J. J. Lerman of Stanford Parlor 76, the Native Sons leased the building from the federal government so restoration could begin. The building passed into the hands of the state park commission in 1927.

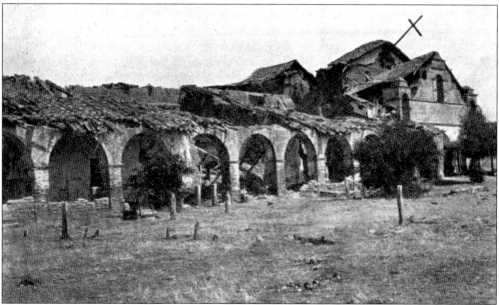

It was not until the late 1940s when a foundation, established by newspaper publisher William Randolph Hearst (a member of Sea Point Parlor 158), stepped forward with a grant that Mission San Antonio de Padua could truly be called "restored." Yet, had it not been for the preservation efforts begun by the Native Sons on September 5, 1903, with the help of descendents of the Mission Indians, when the mission looked like this, by the 1940s there would have been nothing left to restore.

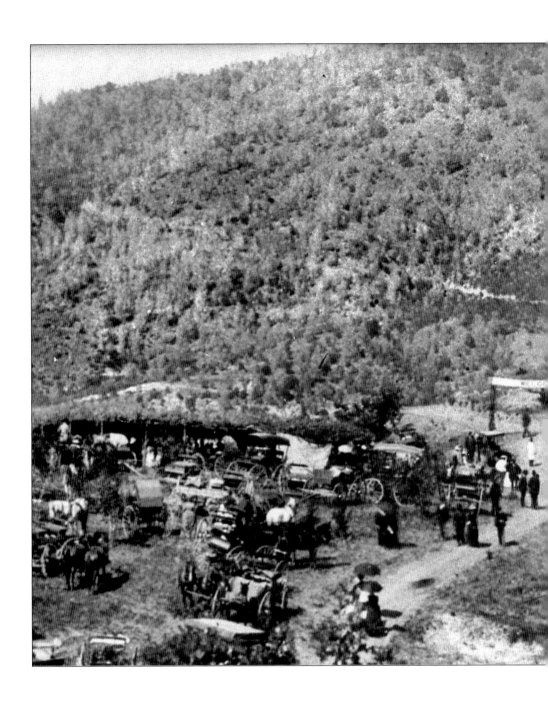

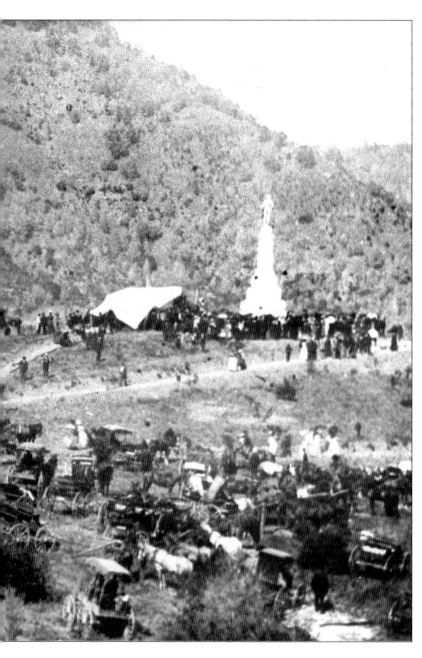

As soon as gold discoverer James W. Marshall died, the Native Sons began urging the state to build a fitting monument to him on a hillside overlooking the gold discovery site at Coloma, on property contributed by Placerville Parlor 9. Those efforts came to fruition on May 3, 1890, when the monument was dedicated, causing this pre-automotive age "parking lot jam."

𝔇edication 𝔈xercises

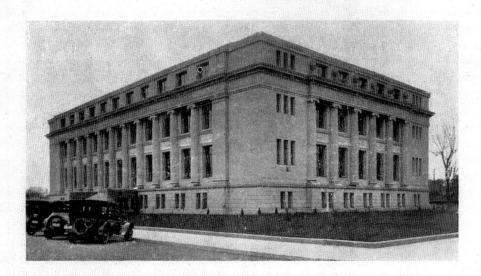

STOCKTON CITY HALL

UNDER AUSPICES

STOCKTON PARLOR, No. 7, N. S. G. W.

ASSISTED BY

OFFICERS OF GRAND PARLOR, N. S. G. W.

STOCKTON, CALIFORNIA

DECEMBER 3, 1926

The dedication of civic buildings—libraries, city halls, county civic centers, fire and police stations—is an important way to build a sense of community among Californians. Here is the program for dedication ceremonies held for the Stockton City Hall in 1926; such activities continue today. For instance, on March 12, 2005, Santa Ana Parlor 74 and a group of Native Son grand officers dedicated the massive new 20-acre, multi-million dollar headquarters of the Orange County Fire Authority in Irvine that serves 22 cities. The new plaque is mounted alongside one that was placed on the headquarters' predecessor building in 1936 by the Santa Ana Parlor.

DEDICATION EXERCISES

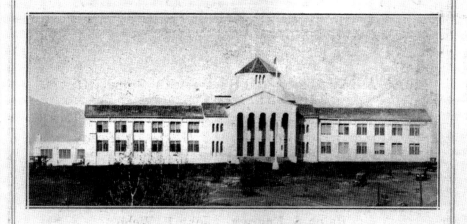

Shasta Union High School

UNDER AUSPICES

McCloud Parlor No. 149, N. S. G. W.

ASSISTED BY

Officers of Grand Parlor, N. S. G. W.

CHAS. A. THOMPSON - - - *Grand President*
HILLARD E. WELCH - *Junior Past Grand President*
JAMES E. WILSON - *Grand First Vice-President*
C. L. DODGE - - *Grand Second Vice-President*
JOHN T. REGAN - - - - *Grand Secretary*

REDDING, CALIFORNIA
DECEMBER 4, 1927

This is the 1927 dedication program for Shasta Union High School is Redding. The school boasted of having a large faculty of 21, including the principal. The size and scope of California high schools has increased tremendously since then.

A group of students at Vallejo's Lincoln School perform a song for members of Vallejo Parlor 77 during June 9, 2003, ceremonies in which Native Sons placed a plaque noting that the property had been the site of a school continuously since 1857. Hundreds of schools throughout the state have commemorative plaques on their grounds that have been placed by the Native Sons over the years. In 2002, for example, the organization marked the Lincoln-Adelaida School that served as the focal point for a rural community west of Paso Robles for a half-century. In 2003, it honored Pleasant Valley School, which has been guiding students in an area east of San Miguel since 1884. In 2004, it marked the restoration of Carrington Hall, the auditorium of Redwood City's Sequoia High School, and it commemorated the 150th anniversary of San Bernardino's Warm Springs School. The organization does more than support education through commemorative markers, it sponsors an essay contest on California history for fourth graders (the grade for which that topic is part of the curriculum). For many years, it sponsored a California history speech contest for high school students. As general interest in public speaking declined, it was discontinued (although some individual parlors, like Ramona 109 in the San Gabriel Valley, continue to hold contests for their localities). It has been replaced by a scholarship program to assist high-school seniors who plan to go on to college, and community-college students seeking to transfer to four-year institutions. A number of parlors supplement that effort with local scholarship programs of their own. Los Banos Parlor 206 holds a legendary drive-through annual pasta sale to raise scholarship money.

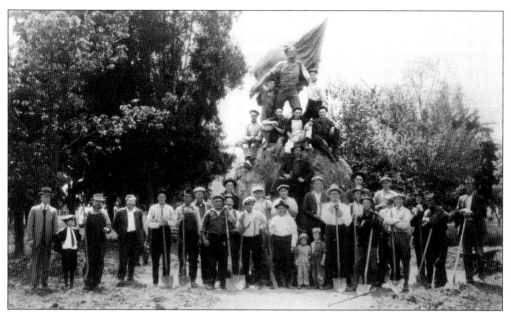

For many years, the site in Sonoma Plaza where the bear flag originally had been raised went unmarked. Largely through the efforts of the Native Sons, the legislature appropriated $5,000 for a monument to be placed there. The Native Sons raised $500 to prepare the site, put on dedication ceremonies, and to move the huge rock that serves as the pedestal from a field about a mile away. Here members of Sonoma Parlor 111 and their children pose as the stature neared readiness for its dedication on June 14, 1914. It is believed that the men in white shirts standing to the right of the monument's base are Armando Bianchini and Joe Keiser, who moved the rock to the site

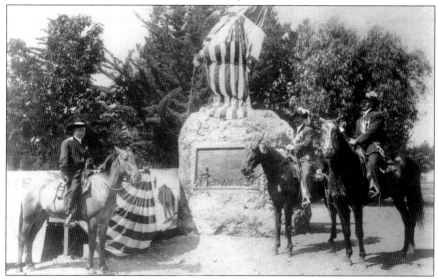

The flag-draped Bear Flag Monument in Sonoma Plaza awaits its dedication June 14, 1914. The horseman at the statue's immediate right is Sonoma Constable Jack Murry. The dedication program by the Native Sons was highlighted by a speech by Gov. Hiram Johnson. Additional festivities included two parades, horse races, fireworks, and dances. In 2000, members of Sonoma Parlor 111 build a low wall and flower bed around the monument to beautify and make it a less attractive climbing challenge for adventurous children.

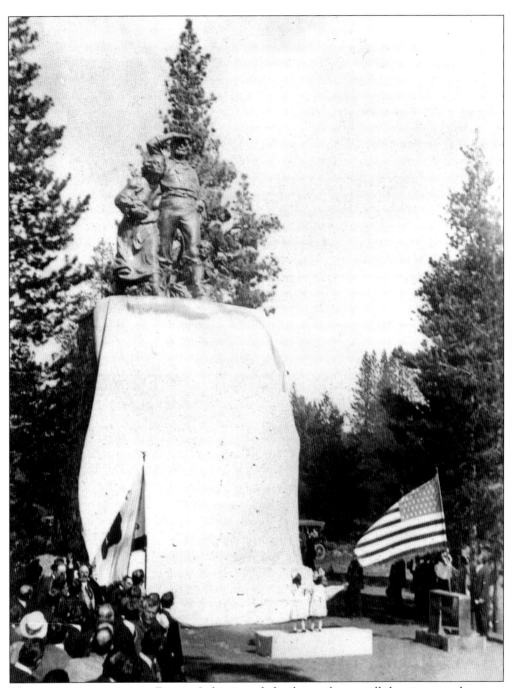

The imposing monument at Donner Lake, intended to be a tribute to all the pioneers who came to California overland by wagon train, was among the earliest ambitious projects the Native Sons embarked on and is one that took many years to bring to fruition. The Grand Parlor endorsed the project in 1898 and designated Dr. C. W. Chapman of Nevada City to spearhead it. Without his great persistence, the $35,000 project probably would have fallen through. It was very expensive for its time—by comparison, the governor made $10,000 annually. The monument's cornerstone was laid in 1910, and it was finally completed and dedicated, as shown here, in 1918.

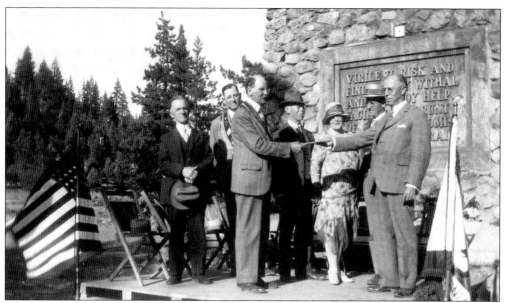

Native Sons Grand President James A. Wilson hands the deed to the Donner Monument and 11 surrounding acres to former state senator Lyman M. King of San Bernardino County, who represented Gov. C. C. Young, on August 18, 1928. This ceremony commemorated the passing of property into the hands of the state park commission.

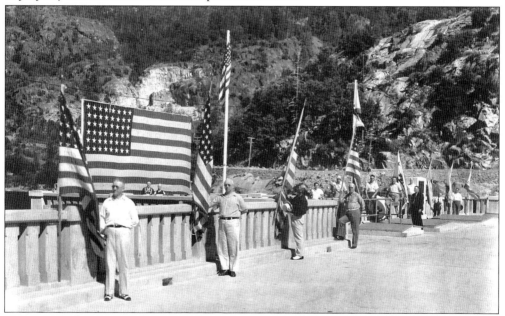

Native Sons flag bearers take their places on O'Saughnessy Dam in preparation for dedication ceremonies they held for the Hetch Hetchy Reservoir in 1940. The Hetch Hetchy system was completed in 1934, but the dam was later enlarged, doubling the reservoir's capacity. This ceremony took place on the enlarged dam. There is a touch of irony here as the Native Sons advocated legislation whereby Yosemite, originally a state park, became a national park. The controversial Hetch Hetchy project dammed the Tuolumne River within national park boundaries, much to the dismay of conservationists like John Muir.

COMMEMORATION

W. G. Paltz

In honor of the acceptance by the California State Park Commission of "Lachryma Montis," the historic home of the late General Mariano Guadalupe Vallejo at Sonoma, for the State of California

Sonoma, California
Friday, July 7, 1933
at one p. m.

The home of General Mariano Guadalupe Vallejo, commandant of the northern frontier of Mexico and founder of Sonoma, was purchased from his family by the state park commission with funds donated by the public. This program marked the acquisition of the house as a historical landmark.

PROGRAM

PART I

SELECTIONS United States Marine Band

GREETINGS . . A. R. Grinstead, *for City of Sonoma*

SELECTION United States Marine Band

ADDRESS . Hon. Joseph R. Knowland, *Member State Park Commission. Chairman Historic Landmarks Committee Native Sons of the Golden West.*

SONGS Sung by Grace Boles Hedge
a. "Solo por ti" (For You Alone) . Francisca Vallejo
b. "La Hora" (The Hour) . . . Francisca Vallejo
c. "Hermosas Fuentes" (Beautiful Fountains)
(Old Mexican) Francisca Vallejo
Francisca Vallejo at the piano

CONGRATULATIONS . H. G. Ridgway, *Chairman Events and Celebrations Committee, Redwood Empire Association.*

RESPONSE . W. F. Chipman, *President General Vallejo Memorial Association.*

SELECTION United States Marine Band

PART II

DANCES Interpreted by Ramona Carrillo
a. Bolero
b. Tango Trieste
c. Los Toros
Music by Francisca Vallejo

ADDRESS . Hon. Emmett Seawell, *Associate Justice of the Supreme Court. Grand President Native Sons of the Golden West.*

VOCAL SOLOS . Mrs. Luisa Vallejo Emparan, *Daughter of the late General M. G. Vallejo.*

ADDRESS . Hon. Lewis F. Byington, *Past Grand President, Native Sons of the Golden West.*

"STAR SPANGLED BANNER"

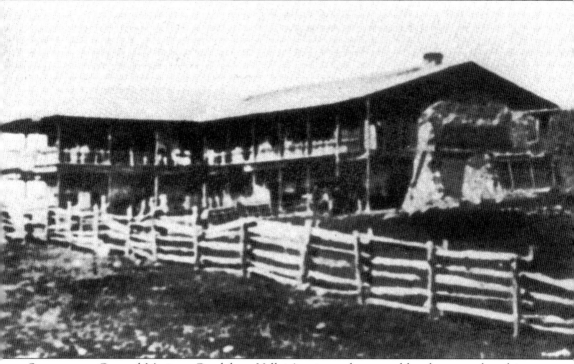

Sonoma was General Mariano Guadalupe Vallejo's primary home and headquarters, but this building, his "casa grande" at Petaluma, served as his summer home for many years. In 1910, the Native Sons' Petaluma Parlor purchased Vallejo's casa grande and managed to preserve it until 1951, when it was conveyed to the state. Like Vallejo's home in Sonoma, it also is now a state park. In the days when California was under Mexican rule, Vallejo was among the highest-ranking Mexican officials in the northernmost province of California to advocate its annexation to the United States, unlike Pio Pico, the last Mexican governor, who openly supported California's colonization by England. It is, therefore, ironic that the Bear Flag Party took Vallejo captive and imprisoned him at Sutter's Fort. The unpleasant experience did not quench Vallejo's generous civic spirit. He subsequently served as a delegate to California's first state constitutional convention and as a member of the first state senate. In April 1850, he proposed to lay out a capital city on the straits of Carquinez, grant 156 acres to the state, and to provide $370,000 to erect public buildings there. In October, 7,477 Californians voted to accept Vallejo's proposition, as opposed to 1,292 to keep the capital at San Jose (Sacramento received 160 votes, San Francisco 25). By that time, though, Vallejo's financial fortunes were declining and donors did not step in to fill the void. A small frame building is all that came of Vallejo's dream. The legislature met there in 1851 and 1852 before the building burned and legislators thus departed to Sacramento (temporarily, though, as that building would soon burn also). In later life, Vallejo became a member of Sonoma Parlor 111 of the Native Sons. In 1889, he sent a telegram to Grand Parlor saying, "Wish you all a successful and joyful gathering. Sickness prevents me from shaking hands with you, but am with you in spirit, and proud to be the oldest member of the Native Sons of California, which promises to be the most prosperous and brightest star of the Union under your control." Within a year, the old general/statesman had died.

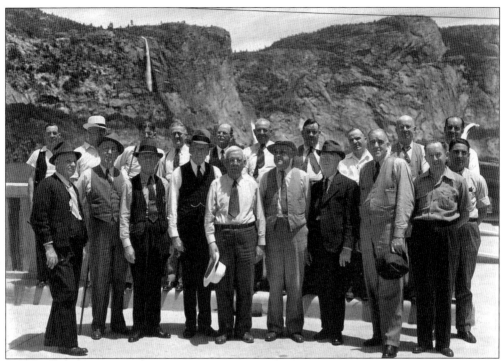

Grand officers of the Native Sons gather on O'Saughnessy Dam after the 1940 Hetch Hetchy dedication. The view in the background provides a glimpse of the Hetch Hetchy Valley and speaks for itself in explaining why many considered the area to be a twin in beauty to Yosemite Valley.

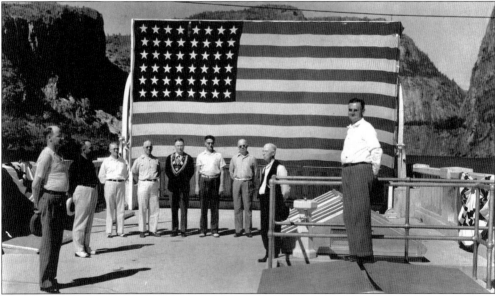

Native Sons grand officers dedicate Hetch Hetchy Reservoir on June 23, 1940. Pictured, from left to right, are Grand 1st Vice President Edward T. Schnarr, Junior Past Grand President Jesse H. Miller, Grand Secretary John T. Regan, Past Grand President 1934 Charles A. Koenig, Grand President Henry S. Lyon, Grand 3rd Vice President Wayne R. Millington, Past Grand President 1935 Hamon D. Shillin, Past Grand President 1902 Louis F. Byington, and Grand Historian Peter T. Conmy.

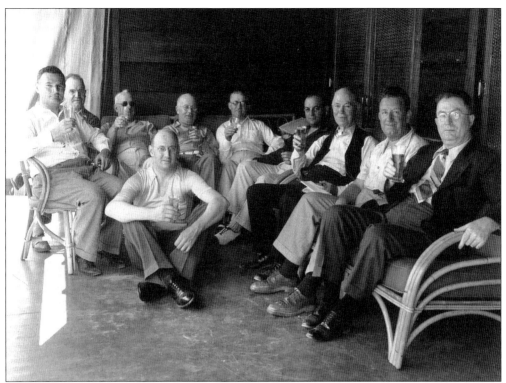

Native Sons grand officers enjoy some relaxation (and some beer) on the porch of a cottage following the Hetch Hetchy Reservoir dedication. Grand President Henry S. Lyon is the only one who has not yet shed his necktie.

1850 1950

HISTORICAL
MARKER DEDICATION

FIRST MASONIC HALL BUILT
IN CALIFORNIA

Sunday, December 17, 1950
Benicia, California

Sponsored by:
BENICIA PARLOR NO. 89, N. S. G. W.
BENICIA PARLOR NO. 287, N. D. G. W.

The Native Sons have always been desirous of acknowledging other fraternal organizations' contributions to California's history, as shown in this program honoring the state's first masonic hall.

In recent years, the Native Sons has dedicated the masonic temple in San Leandro, built in 1910, which served for many years as the meeting place for the Native Sons' Estudillo Parlor 223, and the masonic temple in Auburn, built in 1917. On April 23, 2005, the Native Sons dedicated the Hiram Masonic Building in El Dorado (above), commemorating 150 years of masonry in El Dorado County.

This program announces the dedication of the California Building at the Golden Gate International Exposition. Ten million people attended the 1939 exposition on Treasure Island, which was created to serve as its venue.

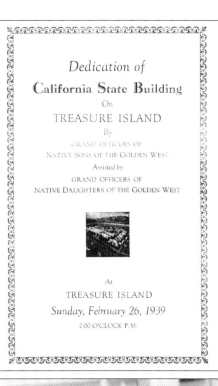

Dedication of
California State Building
On
TREASURE ISLAND
By
GRAND OFFICERS OF
NATIVE SONS OF THE GOLDEN WEST
Assisted by
GRAND OFFICERS OF
NATIVE DAUGHTERS OF THE GOLDEN WEST

At
TREASURE ISLAND
Sunday, February 26, 1939
2:00 O'CLOCK P.M.

Native Sons officers perform dedication rites at the exposition's California Building. Pictured, from left to right, are Grand 2nd Vice President Henry S. Lyon, Grand 3rd Vice President Edward T. Schnarr, Grand President Joseph J. McShane, Grand Secretary John T. Regan, Grand Treasurer John A. Corotto, and Grand 1st Vice President Jesse H. Miller.

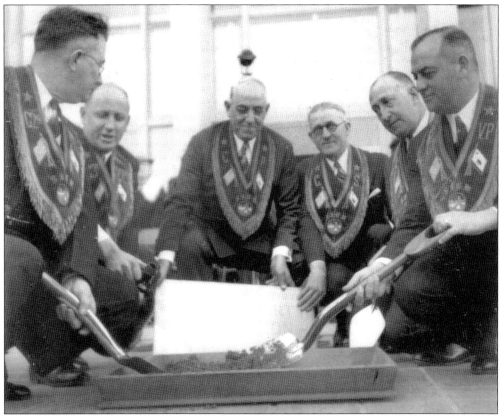

COLUMBIA　　　　　　　　　　　　　MUSEUM

Native Sons of the Golden West

GRAND　　　　　　　　　　　　　OPENING
NOVEMBER 18, 1967
2:00 P. M.

The museum at Columbia is the Native Sons' official gallery for exhibiting its own lore and mementoes. Rockwell D. Hunt, author, educator, historian and member of Ramona Parlor 109, was the founding president of the Conference of California Historical Societies. He selected Columbia as the site for the conference's first symposium in 1954. The Native Sons co-sponsored the conference's golden anniversary symposium, held in Columbia and Sonora in June 2004.

Ordinarily, the Native Sons would buy historic sites and present them to the state. Here it worked the other way around. Columbia is an old mining town that almost, but not quite, became a ghost town. As it was gradually abandoned and deteriorating, there was mounting concern that its potential as a museum-community might be lost forever. As early as 1922, H. C. Peterson of the Historical Research Department of the California State Library and the Native Sons urged the state to acquire the entire town and make it a historical park. It finally happened in 1945. Thus, this building, the meeting hall for Columbia Parlor 258, passed from the organization to the state. The Native Sons leases back the building (the upstairs is still used as an active meeting hall) to use as a museum offering displays of past and current Native Sons activities.

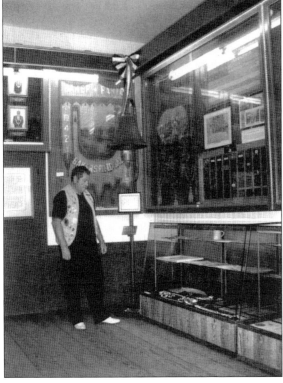

Millard Smallin of Chispa Parlor 139 is curator of the museum at Columbia. Through his efforts, many items have been added to its collection and it has been made more "viewer friendly" for the thousands of visitors it receives each year.

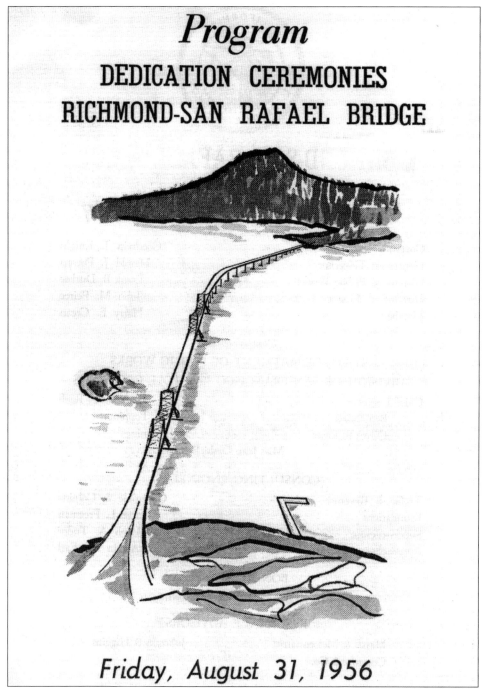

Program
DEDICATION CEREMONIES
RICHMOND-SAN RAFAEL BRIDGE

Friday, August 31, 1956

This program marks the end of an era. In 1930, some 30 lines of ferry boats carried 61 million passengers annually across San Francisco Bay. The opening of the Bay Bridge in 1936 and the Golden Gate Bridge in 1937 put many of them out of service. With the opening of the Richmond-San Rafael Bridge in 1956, the golden age of ferry boats ended. They all but vanished from the bay until the 1970s, when smaller versions of high-speed ferries replaced the older versions. Mount Tamalpias Parlor 64 provided the first bear flag to fly over the toll plaza.

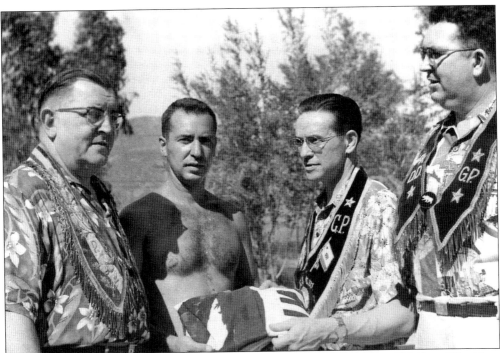

In one of the more unusual events in Native Sons history, on September 4, 1955, Grand President David W. Stuart presented a bear flag to Oakdale Ranch, a nudist resort; it's why the recipient isn't wearing a shirt (or anything else, for that matter). Looking on are Judge Donald E. Van Luven, then president of Arrowhead Parlor 110, and H. Edwin Heil, later to become a grand trustee.

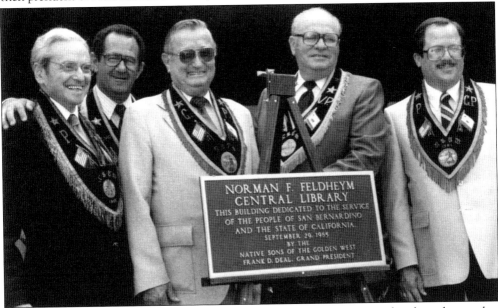

The September 29, 1985 dedication of the Feldheym Library in San Bernardino brought together five persons who, at one time or another, served as grand presidents of the Native Sons. Pictured, from left to right, are David W. Stuart (1954–1955), Frank Compani (1988–1989), Frank Deal (1985–1986), Everett White Jr. (1986–1987), and James Smith (1980–1981).

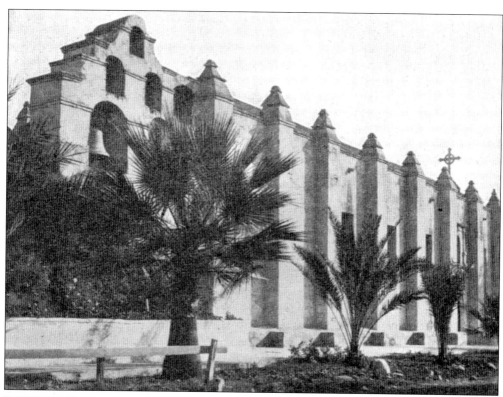

San Gabriel Mission, founded in 1776, is among many of the old Spanish missions that has received special attention from the Native Sons. In 1940, a joint committee of Native Sons and Native Daughters restored its gardens and provided a fountain for them. On March 5, 2005, a group of Native Sons grand officers and Native Daughters Grand Marshal Adeline Coronado held a re-dedication ceremony at the invitation of Ramona Parlor 109 to commemorate the recent refurbishment of the gardens and fountain.

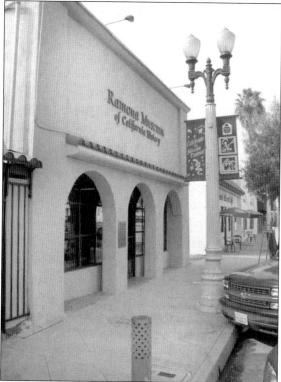

The Ramona Museum of California History stands across the street from San Gabriel Mission at 339 S. Mission Avenue in San Gabriel. Created and maintained by Ramona Parlor 109, it houses a wide variety of artifacts dealing with California history from pre-Columbian times to the present.

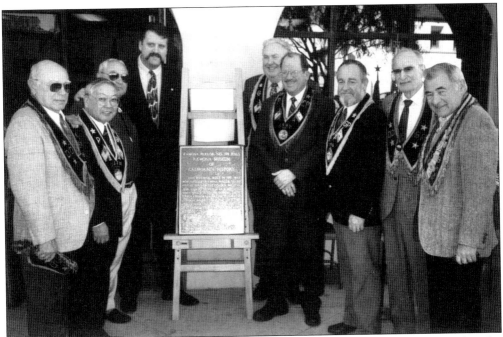

Various Native Sons officials gathered for a "housewarming" on February 3, 2000, after the Ramona Museum, which originally had been in Highland Park, relocated to its present site. Pictured from left to right, are L. R. Utter, Philip Wong, Frank Claro, Clare McCullough, James Riley, James Smith, Richard Hoffmann, Harry Beardo, and George Carone. Wong (1993–1994), McCullough (2000–2001), Riley (1999–2000), Smith (1980–1981), and Hoffmann (1998–1999) all served as grand presidents.

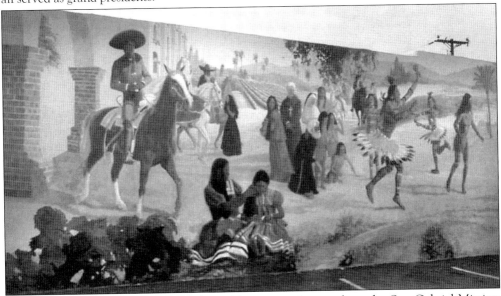

In 2003, Ramona Parlor 109 decided to add an attractive touch to the San Gabriel Mission District, which also is home to the San Gabriel Playhouse. So it commissioned Western muralist Donald Putnam to create this modern-day landmark at the entrance to the parlor's meeting hall behind its museum.

RE-DEDICATION

NATIVE SONS BUILDING

NAPA, CALIFORNIA

AS A

HISTORICAL MONUMENT

BY

Native Sons of the Golden West

NAPA PARLOR No. 62, N.S.G.W. and
NATIVE SONS HALL ASSOCIATION
MAY 9, 1965 - 2:00 P.M.

Some structures created by the Native Sons have become landmarks in their own right; such is the case of Napa Parlor 62's hall, built in 1914. Well aware of its importance as a landmark, the parlor noted its status with a dedication nearly a half century ago.

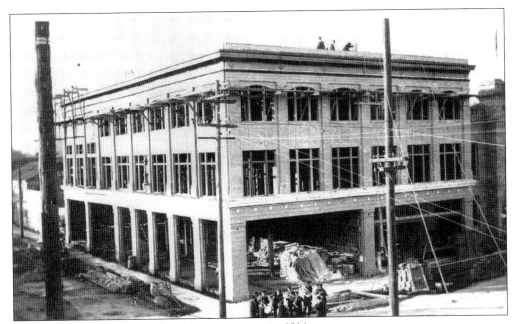
Napa Parlor's hall is pictured under construction in 1914.

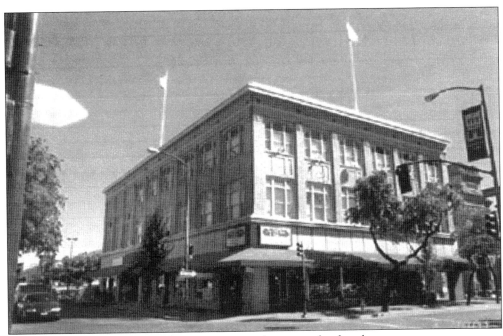
Napa Parlor's hall continues to be an important downtown landmark.

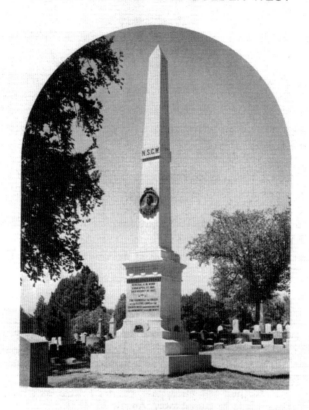

FOUNDERS DAY

NATIVE SONS OF THE GOLDEN WEST

PIONEER CITY CEMETERY, SACRAMENTO

SEPTEMBER 28, 1969

3:00 P.M.

Albert M. Winn did something few do when he founded an organization that he, himself, was ineligible to join because he had been born in Virginia. He nurtured the fledgling Native Sons of the Golden West, presiding over training sessions to teach its young officers the fine points of parliamentary procedure and debate. He was made an honorary member, but on April 26, 1876, the organization voted to prohibit honorary memberships and thus his name was stricken from the rolls. Winn died August 25, 1883, and five years later the Native Sons erected a massive monument to adorn the grave of their founding non-member. Throughout the years they have regularly held observances there to honor him.

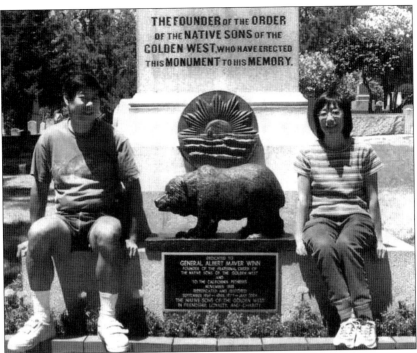

Over the years, vandalism and the elements took their toll on the Winn Monument. Grand Trustee Steve Wong of Sunset Parlor 26 (shown here with his wife, Paula, at the monument's base), initiated a restoration project, which was completed in July 2004. The ornamental bronze bear in the center was restored through the craftsmanship of James Caron, a member of Rio Hondo Parlor 294.

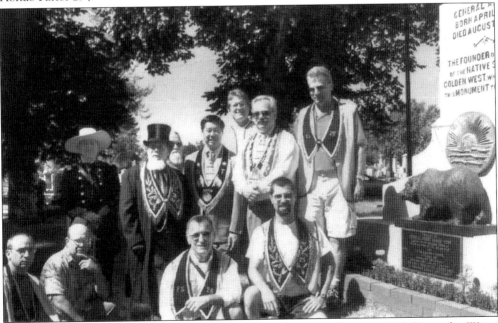

Members of Sunset Parlor 26, who had spent many hours working to rehabilitate the Winn Monument, gather around it after it was rededicated on July 11, 2004.

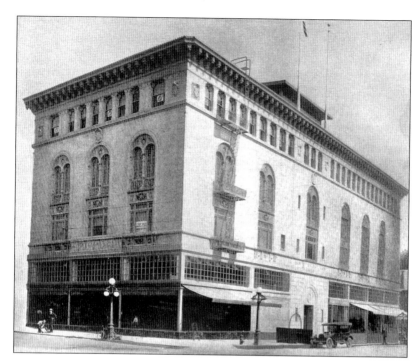

Sadly enough, sometimes even organizations devoted to history allow their own history to slip away. When Sacramento Parlor 3 disbanded in the 1960s, its meeting hall at Eleventh and J streets, built in 1917 (a virtual twin to the one in Napa), was sold and razed.

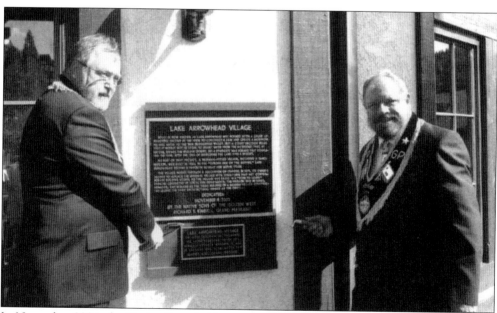

In November 2004, the Native Sons held a unique, two-plaque ceremony at Lake Arrowhead Village in the San Bernardino Mountains. Everything was ready to perform the dedication on November 8, 2003, but forest fires, while sparing the village, cut off electricity and road access, forcing postponement of the dedication. It was finally held a year later, using the original plaque, plus a supplementary plaque explaining the delay. Here Grand Presidents Barney Noel (2004–2005) and Richard Kimball (2003–2004) dedicate the two plaques.

Four

CELEBRATING
AND SOCIALIZING

If you are a member of a fraternal organization, it stands to reason that you will do a lot of fraternizing, and Native Sons of the Golden West are adept at it. The pursuit of distinguished ideals, such as preserving the history of California, can be a great deal more fun if you (and your family) can socialize with friendly people. That agreeable form of diversion is one the Native Sons have always done well.

Individual parlors have a multitude of social activities, most that evolve around the breaking of bread. Crab feeds are a mainstay of many parlors, drawing hundreds of participants at a time. If one has a taste for corned beef, he or she will find it being served virtually every night of March at some parlor up or down the state. There are dances and picnics, and barbecues of all varieties are a specialty. December brings a seemingly endless round of Christmas parties. The organization also offers participants a chance to dress, if they wish, in costumes of the gold rush or at least the Victorian era.

Native Sons gather for festive repasts at the drop of a hat. Typical annual events that serve as grounds for such regalement are, of course, Admission Day (celebrated in recent years in conjunction with Old Sacramento's Gold Rush Days); Southern California Weekend, a movable feast that has traveled in recent times from such locations as Catalina and Anaheim to Temecula and Lake Arrowhead; the anniversary of the discovery of gold on January 24, an event that used to be observed by a banquet in the San Francisco Bay area, but has moved in recent years to the Mother Lode; the De Anza Trek, hosted by De Anza Parlor 312 in the Imperial Valley; Weekend in the Redwoods, held in Humboldt County; Forty-niner Days, which naturally needs to be in the Mother Lode; and Flag Day, which takes place in the Sonoma Plaza where the bear flag was originally raised.

A number of parlors offer athletic outlets for their members, such as softball, bowling, golf, and bocce ball. In addition to these pleasurable diversions, there is a more serious side to Native Sons associations. In the days before there were social programs that served as safety nets, the Native Sons was a mutual benefit society. By the advent of World War I, it had already paid out $1.5 million for the relief of its sick and financially distressed members. Times have changed, so that form of charity is no longer needed and thus the Native Sons reach out with benevolence to those outside the order. For more than a half-century, the organization has donated what now amounts to more than $3 million to California hospitals for research and treatment of children with cleft palates and similar cranio-facial anomalies. In 2005–2006, the Native Sons' Charitable Foundation will present $110,000 to the University of California at San Francisco (the only UC campus dedicated solely to graduate and professional study in the healing arts), $60,000 to St. John's Health Center in Santa Monica, $35,000 to Sutter Memorial Hospital in Sacramento, and $5,000 to the Children's Hospital and Research Center in Oakland.

Parlors also engage in various forms of community service. For example, Fairfax Parlor 307 has refurbished the picnic facilities of nearby Samuel P. Taylor State Park; Auburn Parlor 59, Georgetown Parlor 91, and Placerville Parlor 9 have mended fencing at Coloma State Park; and in June 2005, Napa Parlor 62 provided a safe and sober graduation night party/barbecue for 900 of its community's high-school seniors.

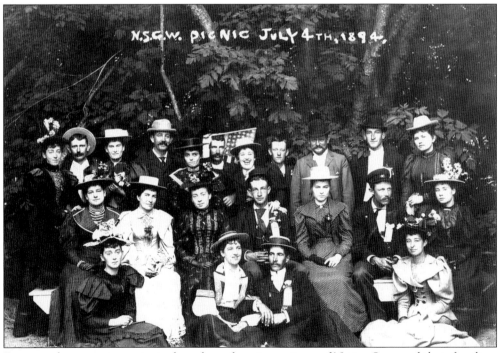

For more than a century, picnics have been favorite pastimes of Native Sons and their families.

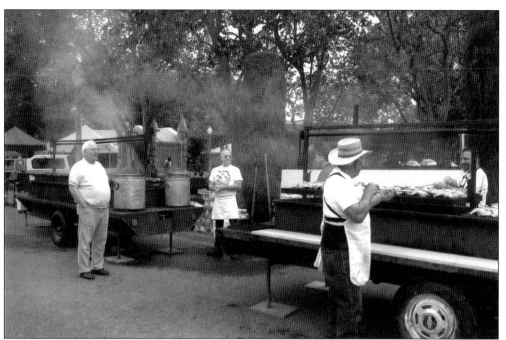

Being fed well still is important to Native Sons. Here cooks from Sonoma Parlor 111 prepare to feed hundreds of chickens to visitors who would attend the 2003 Flag Day barbecue.

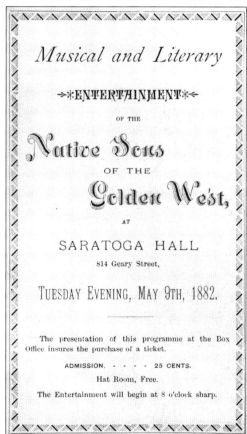

Musical and Literary

→∗ENTERTAINMENT∗←

OF THE

Native Sons

OF THE

Golden West,

AT

SARATOGA HALL

814 Geary Street,

TUESDAY EVENING, MAY 9TH, 1882.

The presentation of this programme at the Box Office insures the purchase of a ticket.

ADMISSION. - - - - 25 CENTS.

Hat Room, Free.

The Entertainment will begin at 8 o'clock sharp.

This evening's entertainment in 1882 included piano, flute, and vocal solos and "favorite melodies by the Native Sons Chorus."

Tenth Anniversary

California Parlor

No. 1

Organized July 11, 1875.

Mechanics' Pavilion

FRIDAY, JULY 10, 1885.

FRANK EASTMAN & CO., PRINT, 509 CLAY ST.

Mechanics Pavilion was the venue for many San Francisco festivities such as this one. On the morning of April 18, 1906, it would become an impromptu emergency ward for earthquake victims because the municipal hospital had collapsed. By noon on that fateful day, its hundreds of patients had been hastily evacuated to hospitals at the Presidio. Within hours, the pavilion lay in ashes.

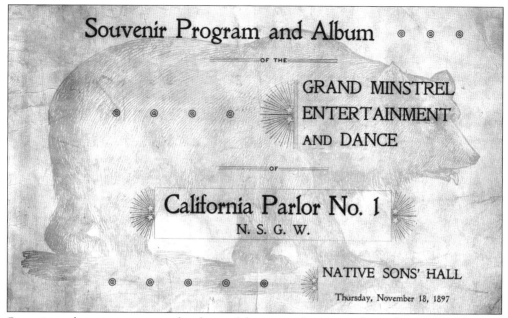

Souvenir Program and Album

OF THE

GRAND MINSTREL
ENTERTAINMENT
AND DANCE

OF

California Parlor No. 1
N. S. G. W.

NATIVE SONS' HALL

Thursday, November 18, 1897

Sometimes the programs seemed to be as elaborate as the events themselves, as was the case with this 1897 gala.

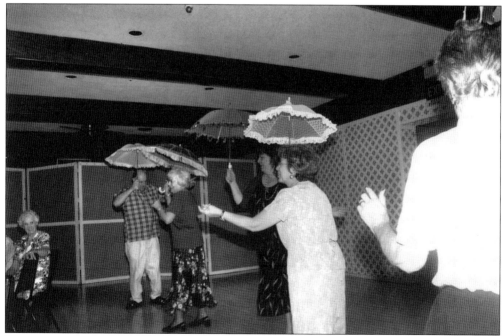

These parasol-waving dancers at Halcyon-Alameda Parlor 47's anniversary dinner arrived at least a century too late to see a minstrel show, but they seem to be having fun anyway.

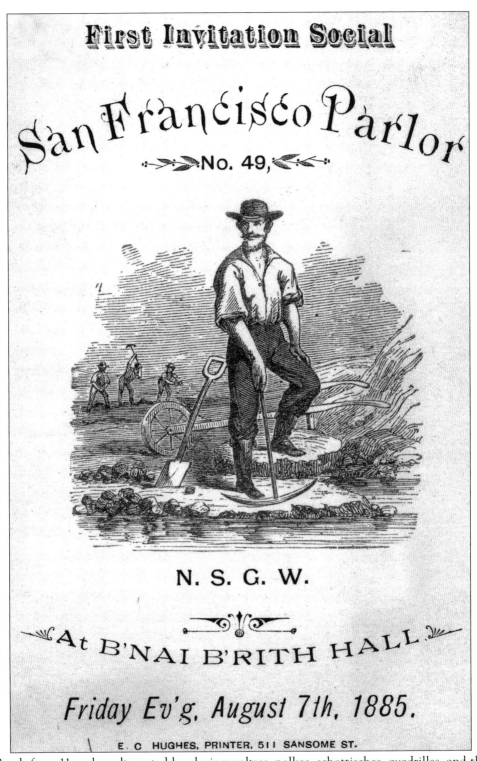

Bands from 11 parlors alternated by playing waltzes, polkas, schottisches, quadrilles, and the mazurka for this 1885 event.

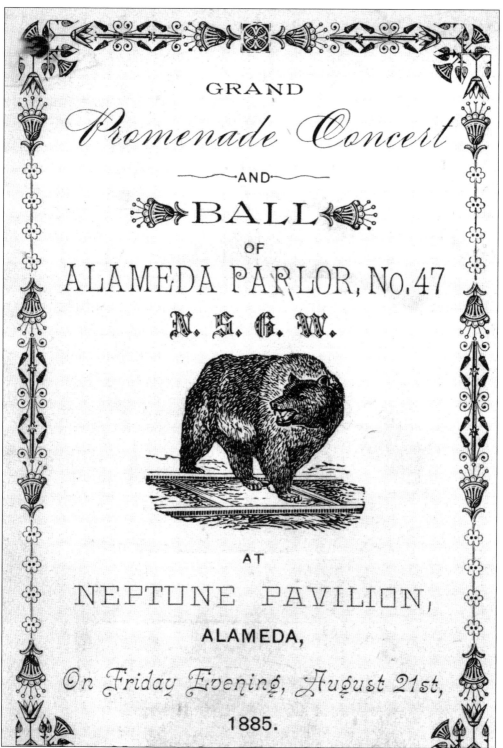

GRAND

Promenade Concert

—AND—

BALL

OF

ALAMEDA PARLOR, No. 47

N. S. G. W.

AT

NEPTUNE PAVILION,

ALAMEDA,

On Friday Evening, August 21st,

1885.

This evening of dancing and musical entertainment offered by Alameda Parlor 47 in 1885 was followed by a reception.

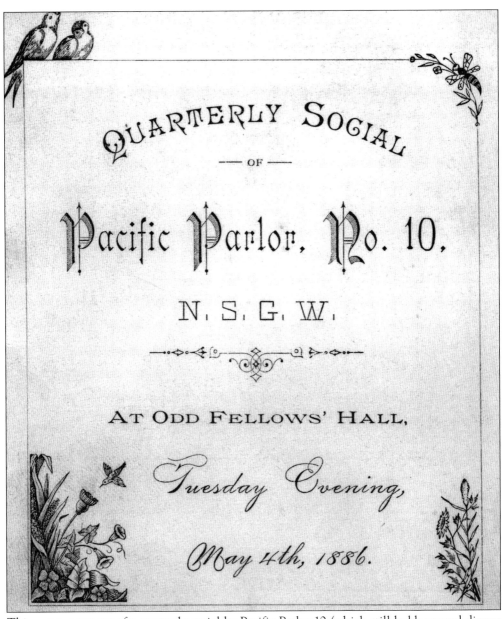

QUARTERLY SOCIAL

— OF —

Pacific Parlor, No. 10,

N. S. G. W.

AT ODD FELLOWS' HALL,

Tuesday Evening,

May 4th, 1886.

This announcement of a quarterly social by Pacific Parlor 10 (which still holds annual dinner dances) suggests that a cycle of at least quarterly social events were the habitual routine for parlors of the day. It could help explain why the late 1880s were years of growth for the organization in an era when fraternal orders were anchors of communities' entertainment.

FIRST ANNIVERSARY

CONCERT & BALL

TO BE GIVEN UNDER THE AUSPICES OF

Santa Cruz Parlor, No. 90,

N. S. G. W.,

——AT THE——

PAVILION,

—— ON ——

Friday Evening, August 19th.

Santa Cruz Parlor 90 was one of many new parlors that received their charters in 1886 and 1887. The fledgling parlor lost no time entering into the social tempo of the times.

Sunset Parlor, N. S. G. W.

Come and See Them Ride the Goat

Arnold Patterson and C. F. (Judge) Waymire will be the Star Performers on Monday evening, July 8th. Also Installation of Officers and a Jolly Good Time.

Come and let's hear your views on the Admission Day Celebration at Stockton.

E. E. REESE,
Secretary.

F. A. PRIOR,
President.

"PAT"

"JUDGE

One has to wonder how much serious planning for Admission Day was accomplished while members enjoyed this "jolly good time" in 1912.

ANNOUNCEMENT

MONTHLY RAG DANCE

TO BE GIVEN BY THE

Native Sons and Native Daughters
of the Golden West

NATIVE SONS AUDITORIUM

430 MASON ST., NEAR GEARY

Thursday Evening, August 20th, 1914

Admission, 25 Cents

Piano Box Music

Dancing at 8:30 o'clock

The Jazz Age had yet to dawn in 1914, so Native Sons and Native Daughters were still making the most of the ragtime era.

M *W. J. Contente* and Friend

You are cordially invited to be guests of

Oak Park Parlor, No. 213

Native Sons of the Golden West

on the evening of June second
nineteen hundred and sixteen
at Joyland Pavilion

Informal Dansant

Joyland Gate and Pavilion

The Joyland Pavilion was "the place to go" for the younger, smart set in the Sacramento area in the early years of the 20th century. The bearer of this invitation could look forward to an enjoyable evening there in the then-suburb of Oak Park.

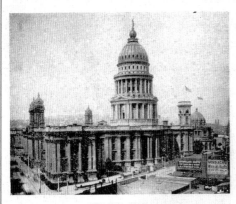

CITY HALL DOME.

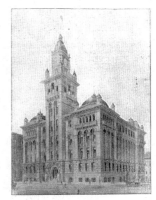

HALL OF JUSTICE.

SHEA & SHEA, ARCHITECTS

26 MONTGOMERY STREET, SAN FRANCISCO

Advertisements in Native Sons publications over the years provide a glimpse at the passing scene. Everything from architects boasting new San Francisco civic buildings that nine years later would fall to the 1906 earthquake and fire to the latest conveniences in household fixtures found their way into the ads.

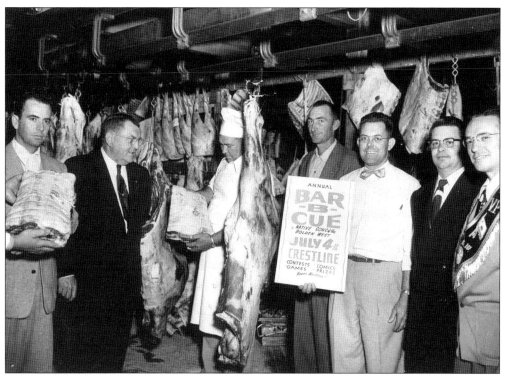

Members of Arrowhead Parlor 110 take state senator James Cunningham (second from right) on a 1953 tour of a packing plant to inspect the fare for their upcoming Fourth of July barbecue.

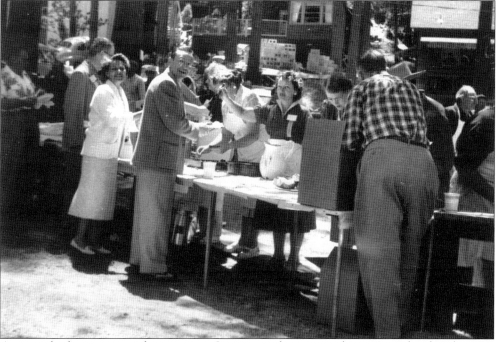

Apparently the meat passed inspection. Guests eagerly consumed it at Arrowhead Parlor 110's Crestline retreat in the San Bernardino Mountains.

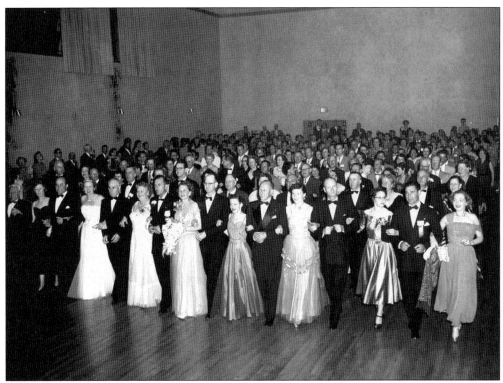

An enthusiastic crowd steps off at the Native Sons' annual Grand Ball in Sacramento in 1954.

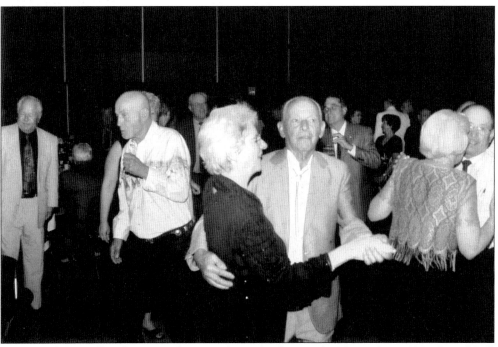

Less formal, but still enthusiastic, dancers take to the floor at the Native Sons' 2004 Grand Ball a half-century later.

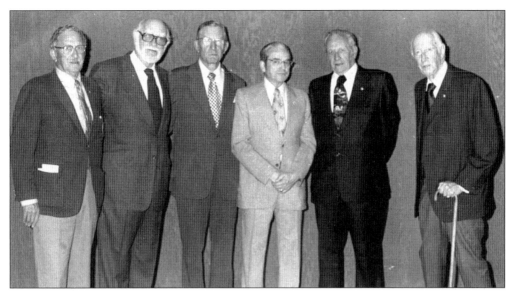

Walter Odemar (second from right), who served as grand president in 1947–1948, was honored in 1977 at a Ramona Parlor 109 dinner for his 55 years of membership in the Native Sons. Joining him were past grand presidents (from left) Andrew Stodel 1968–1969, John Schmolle 1959–1960, Alfred Peracca 1956–1957, David Stuart 1954–1955, and (with cane) Eldred Meyer 1937–1938.

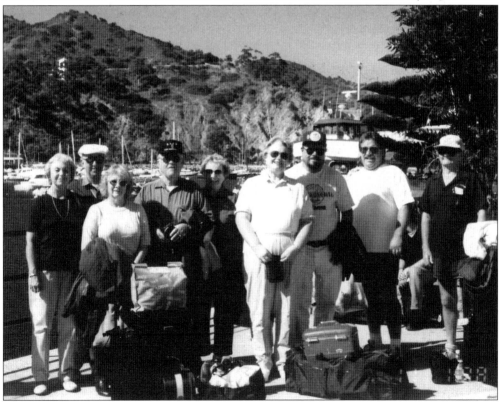

Native Sons annual events are often held in resort settings, such as this Southern California weekend in Catalina Island. Here participants arrive at the Avalon mole on October 30, 1999.

Members of Auburn Parlor 59 have made the restoration of horse-drawn wagons of yesteryear their hallmark. The star of their non-motorized fleet is this mudwagon. Mudwagons are a type of stagecoach designed to travel over rough terrain.

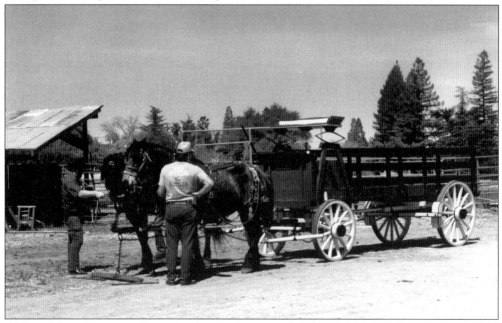

Although less glamorous than other kinds of wagons, freight wagons were the reliable anchors of commerce in the 19th century, and Auburn Parlor 59 has restored this good example of that variety of vehicle.

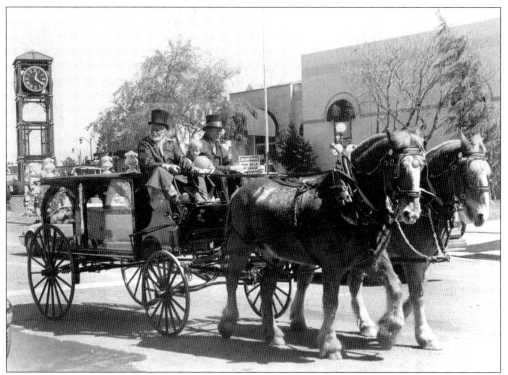

Perhaps there is a bit of Halloween lurking in all of us. In any case, whenever there is a display of horse-drawn vehicles, a hearse always will be a prime attention-getter, and that is true of Auburn Parlor 59's painstakingly restored one.

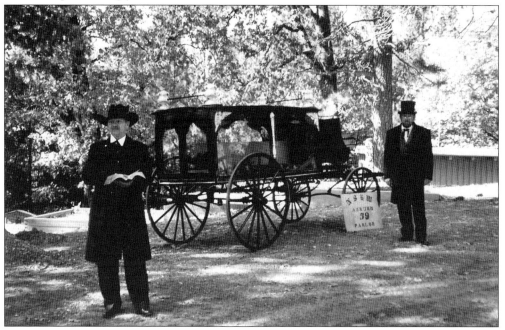

No hearse can achieve the right ghostlike atmosphere without a few stage props, like a coffin to set the correct tone. Auburn Parlor 59 has made sure its hearse has the right embellishments.

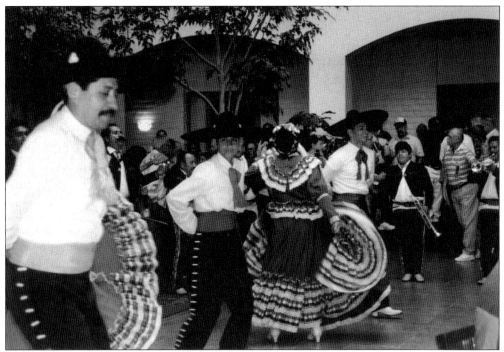

Colorful dancers added to the fiesta theme of Grand President Jesse Garcia's Grand Parlor in 1998.

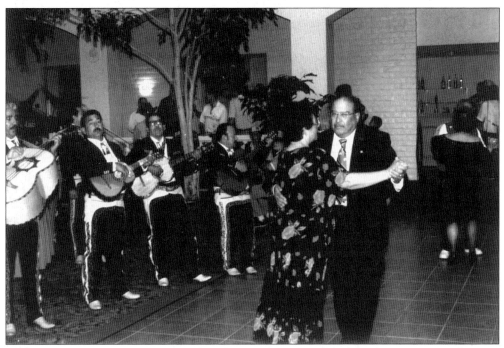

Grand President Jesse Garcia and his wife, Dora, dance as mariachis strum guitars at the 1998 Grand Parlor.

If ever the Native Sons had an "honorary godmother" it had to have been Helen Ping Gum Wong, mother of Philip Wong, who served as grand president in 1993–1994. Before her death in 2003, at age 84, Mrs. Wong was a friendly and gracious presence at countless social events. Here she is dressed up to enjoy an Old Spanish Days fiesta in Santa Barbara.

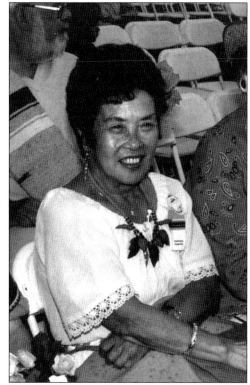

Walton P. Rego served as grand president in 1965–1966. During the remaining 39 years of his life, he planned, organized, and presided over many hundreds of Native Sons social and ceremonial events, especially those based in Alameda County. Here, with his wife Vivian, he enjoys one of the many pre–Admission Day dinners he helped to organize.

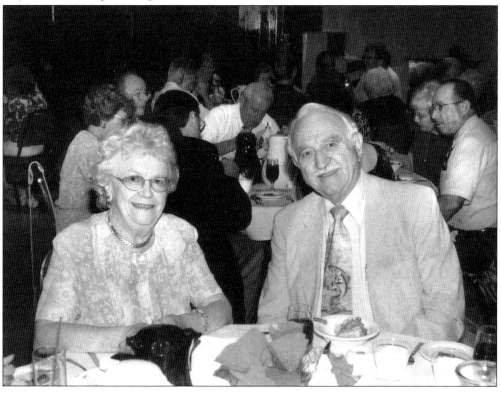

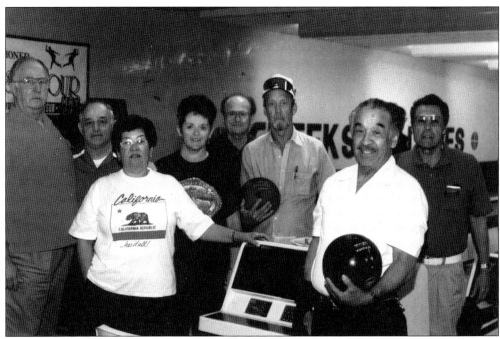

Bowling is among the athletic pastimes of the Native Sons. These teams from Guadalupe Parlor 231 and Santa Barbara 116 prepare to compete at the 1998 Grand Parlor tournament.

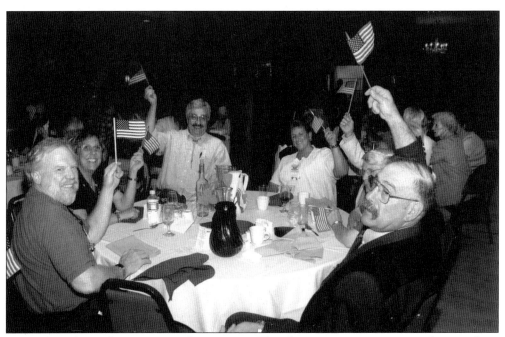

Native Sons have always promoted patriotism. This flag-waving group managed to combine patriotism with pleasure at a 2003 pre–Admission Day dinner

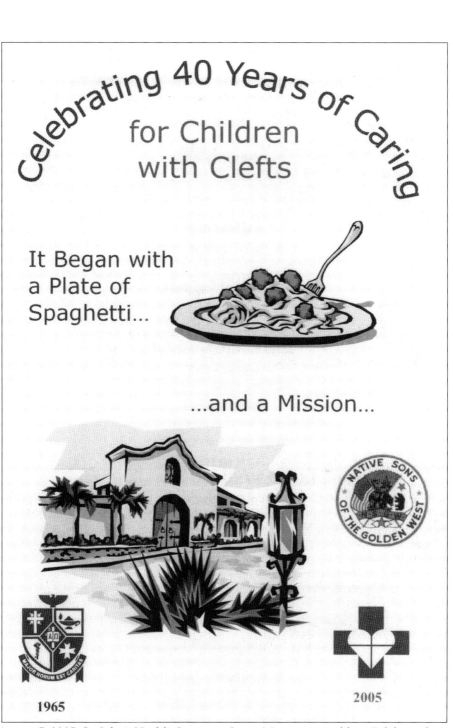

Celebrating 40 Years of Caring

for Children
with Clefts

It Began with
a Plate of
Spaghetti...

...and a Mission...

1965

2005

On August 7, 2005, St. John's Health Center in Santa Monica, one of four California hospitals whose programs to correct facial anomalies are financially assisted by the Native Sons' charitable Foundation, celebrated its fortieth year of working with the organization. Over the years, the Charitable Foundation had donated gifts exceeding $1 million to St. John's. During that time, more than 500 children have benefited from treatment at St. John's as a direct result of Native Sons contributions.

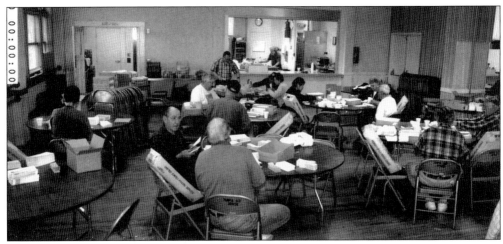

Each year, the Native Sons makes a fundraising appeal to its members to help support its essay contest, charitable foundation, and similar activities. Here members are engaged in one of their annual envelope-stuffing parties for the appeal. Because it receives so much volunteer support to sustain its operations, the charitable foundation is able to keep its overhead expenses to less than one percent of the funds it receives.

Lott's Lake offers a primitive camping experience for Native Sons and their families. At 7,000 feet in Feather River country, the lake is in extreme western Plumas County. A 100-year-old cabin, with its massive stone fireplace and impressive front-porch view, is the main gathering place, but visitors customarily camp in tents, RVs, or under the stars. A visit to the lake requires "considerable self-sufficiency," but is a gratifying experience for those who enjoy roughing it. The lake was bequeathed to the Native Sons in 1957 by Cornelia Sank, daughter of pioneer Charles Fayette Lott.

Five

PROMINENT
CELEBRANTS

Throughout the years when the Native Sons of the Golden West have planned celebrations of California's statehood, they have not had to look very far to find high civic officials to lend bearing to the occasion because many of California's most distinguished sons also have been members of the Native Sons. Six of the state's seven native-born governors were members of the fraternal order.

Romaldo Pacheco of Alcatraz Parlor 145 was one. Pacheco, born in Santa Barbara, served as governor from February 27 to December 9, 1875, during the period when the Order of Native Sons was founded. Although his tenure as governor was brief, he was known for pleading for a statewide irrigation policy and providing sufficient funding to make the University of California a world-class institution. Pacheco served as a representative in Congress from 1877 to 1883, and later as ambassador to several Latin American nations. His father served as an aide to Manuel Victoria, the fourth Mexican governor of California.

George C. Pardee, of Oakland Parlor 50, was a physician born in San Francisco who was also mayor of Oakland from 1893 to 1895 and governor from 1903 to 1907. Known for his ardent support for the conservation of natural resources, he was widely supported throughout the country as a potential running mate for Theodore Roosevelt in 1904. He won much acclaim for his response to the disaster created by the San Francisco earthquake and fire of 1906.

Hiram W. Johnson, of Sunset Parlor 26 and native of Sacramento, ushered in the Progressive era as governor from 1911 to 1917. His administration established the eight-hour labor law for women and children, the Workman's Compensation Act, the Pure Food Act, more stringent regulation of railroads and public utilities, pensions for retired teachers, the Civil Service System, and direct primary elections to replace the practice of nominating by conventions. After leaving the governorship, Johnson served for 28 years in the U.S. Senate.

James Rolph Jr., of Hesperian Parlor 137, was born in San Francisco and served as mayor of that city for 19 years, beginning in 1911. He was elected governor in 1930 after conducting a picturesque campaign in which he visited every county seat by airplane. With his buoyant personality, "Sunny Jim" traveled often throughout the state to boost citizens' spirits during the Great Depression. He died in office on June 2, 1934.

Earl Warren, of Fruitvale Parlor 252, was a native of Los Angeles who served as governor from 1943 to 1953. He is the only person to have been elected governor three times, and he was the Republican nominee for vice president in 1948. During Warren's gubernatorial years, California grew faster proportionally than any other state in history. He presided over the most massive building program ever undertaken by any state, and no other governor in American history shepherded the construction of so many schools, colleges, highways, hospitals, prisons, and public works projects in such a short time frame. Warren resigned as governor to become chief justice of the United States, a post he held until 1969.

Edmund G. (Pat) Brown, of South San Francisco Parlor 157, another native of San Francisco, served as governor from 1959 to 1967. Like Warren, Brown presided over a period of great growth and expansion of public services. His administration saw the launching of the State Water Project and the Master Plan for Higher Education, the development of state parks and recreational facilities, and the growth of fair employment practices and civil rights laws.

In addition to Hiram Johnson, four more of California's U.S. senators have been Native Sons. Stephen M. White, of Ramona Parlor 109, was a San Francisco native who became a Los Angeles resident, and was senator from 1893 to 1899. James D. Phelan, of Pacific Parlor 10, served as mayor of his hometown of San Francisco from 1897 to 1902, and as senator from 1915 to 1921. An ardent patron of the Native Sons, he provided endowments that offer continuing support for the organization's landmark marking program and to assist its indigent members. William F. Knowland, of Halcyon Parlor 146, was born in Alameda and was the son of legendary Native Sons leader/preservationist Joseph R. Knowland. He served in the Senate from 1945 to 1959, where he was the Republican floor leader throughout the Eisenhower years. Thomas H. Kuchel (pronounced key-cull), of Mother Colony Parlor 281, whose grandparents founded Anaheim in 1859, served in the Senate from 1953 to 1969. His career also included service in both houses of the legislature and he was state controller.

Several Native Sons have held other statewide offices. Warren Porter, of Watsonville Parlor 65, was lieutenant governor from 1907 to 1911. Frederick F. Houser, of Ramona Parlor 109, was lieutenant governor during Earl Warren's first term. Harold J. Powers, of Sacramento Parlor 3, was lieutenant governor from 1953 to 1959. Will C. Wood, of Halcyon Parlor 146, was superintendent of public instruction from 1919 to 1927. Robert C. Kirkwood, of Observatory Parlor 177, served as state controller from 1953 to 1959. Bert A. Betts, who was state treasurer from 1959 to 1967, is a member of Sunset Parlor 26.

A number of Native Sons have been members of the U.S. House of Representatives. Among them are (with their dates of service): Anthony Caminetti, of Excelsior Parlor 31 (1891–1895); Theodore A. Bell, of Napa Parlor 62 (1903–05), who received 48.3 percent of the vote in the 1906 election for governor; Frank L. Coombs, of Napa Parlor 62 (1901–03), whose parents were married at Sutter's Fort in 1844 (the street where the Napa Parlor lodge hall is located is named for those pioneers); Joseph R. Knowland, of Halcyon Parlor 146 (1904–1915), who was Native Sons grand president (1910–1911); Clarence F. Lea, of Santa Rosa Parlor 28 (1917–1949); Arthur M. Free, of Observatory Parlor 177 (1921–1933); Harry L. Englebright, of Hydraulic Parlor 56 (1926–1943); Bertrand W. Gearhart, of Fresno Parlor 25 (1935–1949); John J. Allen, of Piedmont Parlor 120 (1947–1959); Hubert B. Scudder, of Sebastopol Parlor 143 (1949–1959); John F. Shelley, of South San Francisco Parlor 157 (1949–1964), who was mayor of San Francisco (1964–1968); James B. Utt, of Santa Ana Parlor 74 (1953–1971); George E. Brown Jr., of Arrowhead Parlor 110 (1963–1971 and 1973–1999); Glenn M. Anderson, of University Parlor 272 (1969–1993), who also was lieutenant governor from 1959 to 1967; and Mike Thompson, of St. Helena Parlor 53 (1999–present).

Eight Native Sons have sat on the bench of the California Supreme Court: Frank M. Angellotti, of Mount Tamalpais Parlor 54 (1902–1921); William H. Waste, of Berkeley Parlor 210 (1921–1940); Emmet Seawell, of Santa Rosa Parlor 28 (1923–1939), who served as Native Sons grand president in 1933 and 1934; John E. Richards, of Observatory Parlor 177 (1924–1932); Jesse W. Curtis, of Arrowhead Parlor 110 (1926–1945); William H. Langdon, of Modesto Parlor 11 (1927–1939); B. Rey Schauer, of Ramona Parlor 109 (1942–1965); and Homer Spence, of Halcyon Parlor 146 (1945–1964). Angellotti and Waste both served as chief justices.

At least five Native Sons have served as judges of the federal district court, including Philip C. Wilkins of Sacramento Parlor 3, who was the organization's grand president in 1952 and 1953. A number of other Native Sons have distinguished themselves in fields in and out of politics, including Bank of America founder A. P. Giannini, of Stanford Parlor 76, and newspaper baron William Randolph Hearst, of Seapoint Parlor 158.

History will undoubtedly always remember Richard M. Nixon as the first U.S. president to resign. But on a more positive note, he was the first (and only so far) president to be born in California (Yorba Linda) and to be a Native Son (Whittier Parlor 297). He is the only Native Son ever to have served in both houses of Congress as well.

Presidents Herbert Hoover and Ronald Reagan were longtime California residents and were closely identified with the state, but they were not California natives. Hoover was born in Iowa, while Reagan was reared in Illinois. On August 1, 2002, the Native Sons placed a dedicatory marker at Reagan's Rancho del Cielo in the Santa Ynez Mountains.

Gov. George C. Pardee was a member of Oakland Parlor 50. When the disastrous earthquake and fire struck San Francisco on April 18, 1906, Pardee and his staff set up headquarters in Oakland City Hall that afternoon and coordinated relief efforts. He was widely praised for his administrative skills in handling that task.

Emmett T. Seawell (fourth from left), a member of Santa Rosa Parlor 28 and grand president in 1933 and 1934, was a commanding presence both in the Native Sons and in state judicial circles. He was born near Yountville of pioneer parents who arrived in California in 1853. He served on the state supreme court from 1923 to 1939. (He had plenty of Native Son company, from 1927 through 1932, five of the seven Supreme Court justices were members of the order.) Here he is shown with other Native Sons officers presiding over the dedication of famed botanist Luther Burbank's home and gardens as a place of historic interest.

Hiram W. Johnson, a member of Sunset Parlor 26, became a legendary figure in California politics. Native Sons remember him with particular fondness for signing legislation to designate the bear flag as California's official state flag.

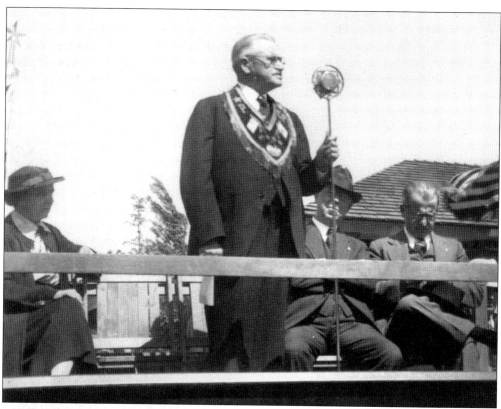

Native Sons Past Grand President Emmet T. Sewell, an associate justice of the California Supreme Court, delivers the principal address at the May 22, 1938 dedication of botanist Luther Burbank's home and gardens in Santa Rosa. Burbank's widow, Elizabeth, looks on. Upon her death in 1977, the property became a museum. Burbank experimented with thousands of plant varieties and developed many new ones, including new varieties of prunes, plums, raspberries, blackberries, apples, peaches, and nectarines.

Frank M. Angellotti was born in San Rafael and was a member of Mount Tamalpias Parlor 64. After serving as district attorney and superior court judge in his native Marin County, he became an associate justice of the state supreme court in 1902. In 1914, he was elected chief justice, serving until 1921.

William H. Waste, a native of Chico and member of Berkeley Parlor 210, served as a state assemblyman and superior court judge in Alameda County. Then, after nearly three years as a presiding appellate court justice, he became an associate justice of the California Supreme Court in 1921. He became chief justice in 1924 and served until 1940.

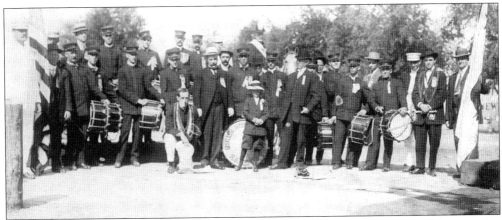

"Sunny Jim" Rolph (in light hat at left of bass drum) was an enthusiastic supporter of his Hesperian Parlor 137. Here he poses with its band in the 1920s while he was mayor of San Francisco. He was elected governor in 1930. Sadly, he collapsed while campaigning for re-election and on June 2, 1934, became the second of California's governors to die in office. (Washington Bartlett, also a former San Francisco mayor who died in 1887, was the first.)

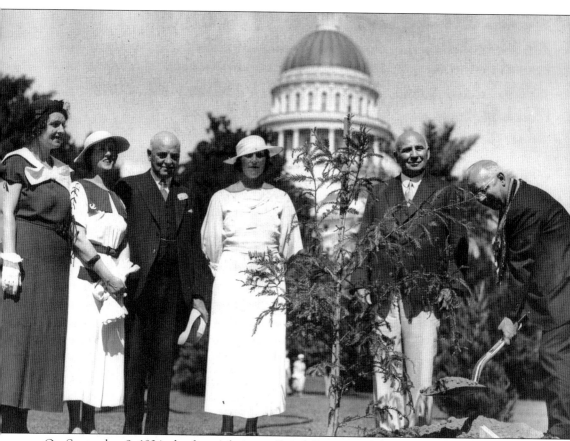

On September 9, 1934, the first Admission Day following Rolph's death, a redwood tree was planted on the state capitol grounds in his memory. The participants were (from left) Native Daughters Grand Marshal Edna Briggs, Native Daughters Grand President Gladys Noce, San Francisco Mayor Angelo Rossi, tree-planting committee Chairman Genevieve Didion, Gov. Frank Merriam (who had been Rolph's chief opponent in the primary election), and Native Sons Grand President Charles A. Koenig wielding the shovel.

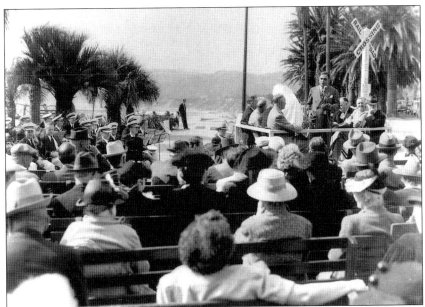

In the early 1940s, several monuments were erected to mark the points at which explorer Juan Rodriguez Cabrillo had landed in 1542. Here, speaking at the dedication of the Cabrillo monument in Santa Monica on October 10, 1942, is legendary Los Angeles County Sheriff Eugene Biscailuz. Under him, the unit became the world's largest sheriff's department. Biscailuz became a deputy sheriff in 1907, and served as sheriff from 1938 until he retired in 1958. He was a member of Santa Monica Bay Parlor 267.

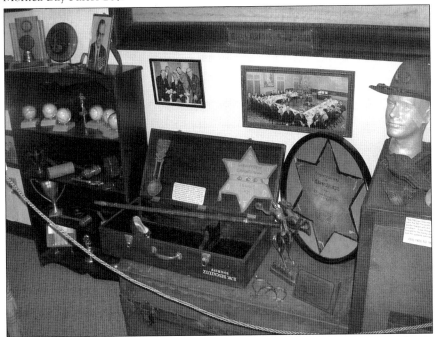

After Eugene Biscailuz's death in 1960, a number of his personal effects were donated to Ramona Parlor 109 (successor to his Santa Monica Bay Parlor by merger.) They are now displayed in a special section of Ramona Parlor's museum that recreates the appearance of his office.

Joseph. R. Knowland, state legislator, congressman, and longtime publisher of the *Oakland Tribune*, probably did more single-handedly to advocate the preservation of California history than any other person ever. He was grand president of the Native Sons in 1910 and 1911, at a time in life when he was also a leader in the California Historical Landmarks League. He would live on to be a past grand president and towering figure in the order for another 55 years. As chairman of the California State Parks Commission (1936–1960), and as a tireless writer on topics concerning California history, he wielded unparalleled influence in movements to preserve California landmarks.

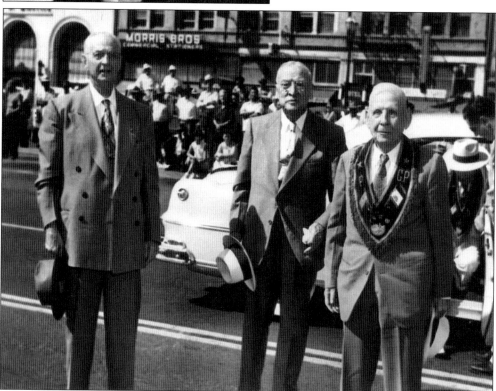

Past grand president Joseph R. Knowland (center) arrives for Stockton's 1953 Admission Day Parade, with past grand president Charles L. Dodge (1929–1930) at the left.

The Order of

Native Sons of the Golden West

in Cooperation with the

California State Park Commission

and the

City of Oakland

requests the pleasure of your attendance at the

Park Dedication and Bronze Bust Unveiling

Honoring Joseph R. Knowland
Past Grand President, N. S. G. W.

and a

Distinguished Californian

on Sunday afternoon, the ninth of September

Nineteen hundred and fifty-one

two o'clock

at

Knowland State Arboretum and Park

Ninety-eighth Avenue and Mountain Boulevard

Oakland, California

In 1951, an Oakland Park was named for Joseph. R. Knowland, a uniquely fitting tribute considering it was because of his efforts that many recreational and historic parks were developed for Californians to enjoy for decades.

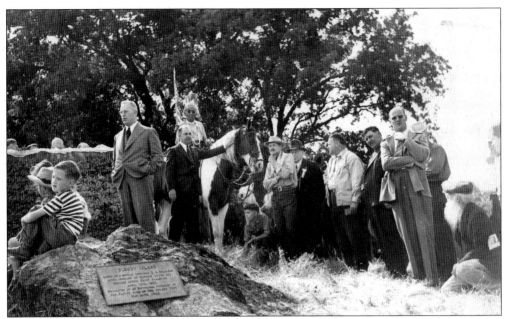

Earl Warren, of Fruitvale Parlor 252 (wearing glasses, standing directly above plaque), California's attorney general, speaks at the May 20, 1942 dedication of Bloody Island in Clear Lake. Mounted on horseback in the background is a great-grandson of Chief Three Feathers. The May 1850 Battle of Bloody Island is an ugly chapter in history. Some settlers, including a member of the Kelsey family for whom Kelseyville is named, had been killed by Native Americans. In reprisal, after months in which ill feelings festered, a detachment of Army infantrymen fell upon a large group of Native Americans on the island and killed them in an attack that history has acknowledged as far out of proportion to the provocation.

Gov. Earl Warren autographed this 1944 Admission Day banquet program. Warren was among California's most history-minded governors. In 1949, he established the California Historical Landmarks Advisory Committee, which brought about the state's program of indicating its landmarks. Before that, the task was left entirely to private groups, such as the Native Sons.

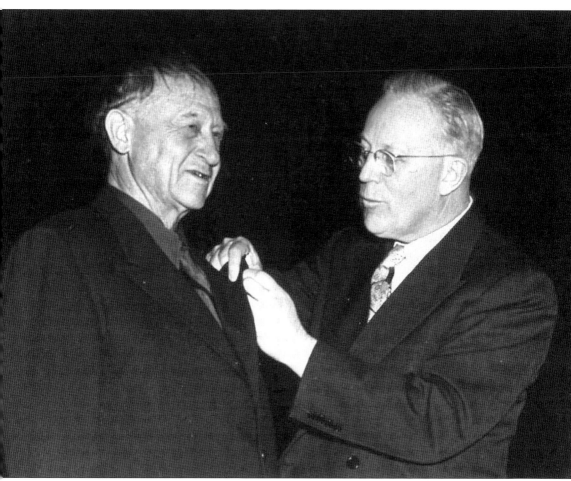

Governor Earl Warren, of Fruitvale Parlor 252, presents a 50-year Native Sons membership pin to state senator Ralph E. Swing, of Arrowhead Parlor 110, on March 11, 1950. Swing, the son of San Bernardino pioneers, served in the Senate for 28 years (a record in its time). He was chairman of the powerful finance committee, and in the late 1930s was one of the key players in developing legislation affecting oil-well leasing on state lands. Swing was to live on eventually to become a 61-year member of the Native Sons.

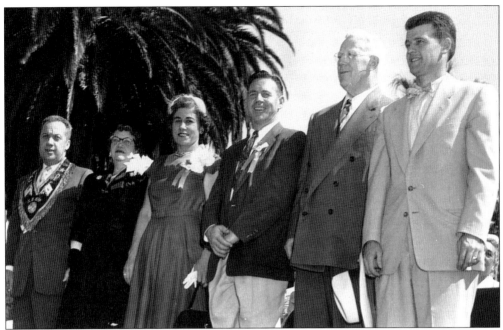

Grand President Philip C. Wilkins (far left), of Sunset Parlor 26, and Gov. Earl Warren, of Fruitvale Parlor 252, review the 1953 Admission Day parade in Stockton. Within a month, Warren would be appointed chief justice of the United States. Wilkins would be appointed a judge of the U.S. District Court for the Eastern District of California 16 years later.

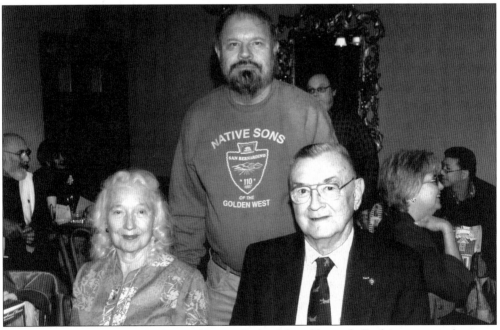

Former state treasurer Bert A. Betts, of Sunset Parlor 26, and his wife, Barbara, enjoy a dinner at his parlor in December 2003 with Grand President Richard Kimball. Betts, 35 years old in 1958, became the youngest person ever elected to a statewide office at the time. The San Diego native was California's treasurer for eight years.

Frederick F. Houser, a Los Angeles native and member of Ramona Parlor 109, was lieutenant governor of California from 1943 to 1947. He received 48 percent of the vote as the 1944 Republican nominee for the U.S. Senate.

Harold J. Powers's family established itself in California during the gold rush days when his grandfather emigrated from Ireland. Powers, born in Modoc County in the far northeastern corner of the state where his family had ranching interests, became lieutenant governor for a seven-year stint in 1953, after serving 21 years in the state senate, eight years as its powerful president pro tempore. He was a member of Sacramento Parlor 3.

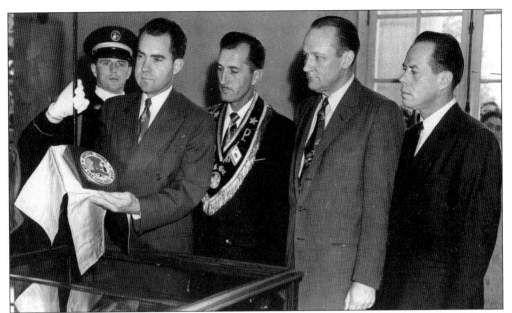

In May 1953, Richard M. Nixon, of Whittier Parlor 297, as vice president of the United States, places a Native Sons seal in the trophy room at Arlington National Cemetery. Looking on are Native Sons Grand President Louis Pellandini and California's two U.S. senators, William F. Knowland, of Halcyon Parlor 146, and Thomas H. Kuchel, of Mother Colony Parlor 281.

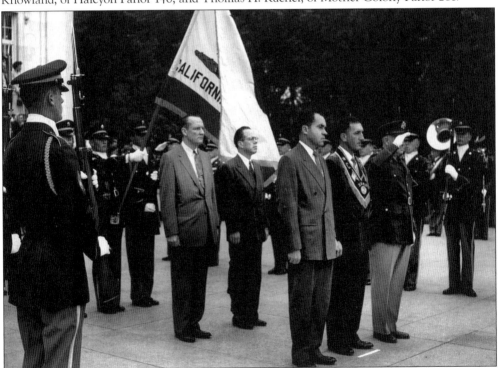

Vice President Richard M. Nixon reviews the changing of the guard at the Tomb of the Unknown Soldier at Arlington National Cemetery. Native Sons Grand President Louis Pellandini (with regalia) stands next to him. Behind them are U.S. Senators William F. Knowland and Thomas H. Kuchel.

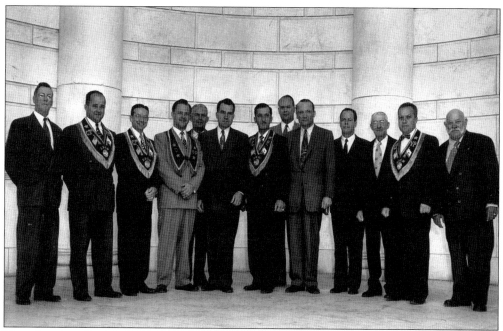

Vice President Richard M. Nixon (sixth from left) and Native Sons Grand President Louis Pellandini, of Sonoma Parlor 111 (at Nixon's right), are flanked by Native Sons grand officers at Arlington National Cemetery.

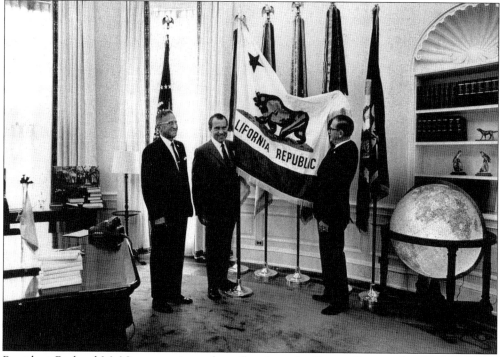

President Richard M. Nixon receives a bear flag from the Native Sons in the Oval Office in 1969. Junior Past Grand President Andrew M. Stodel stands at his left. Grand President Richard L. Ritchison holds the flag.

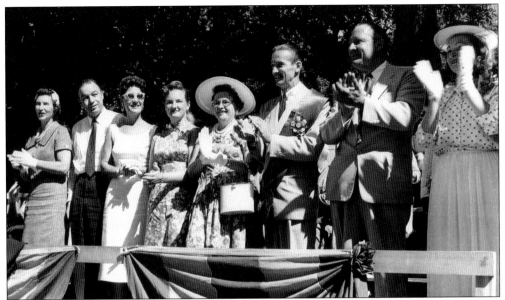

Among those on the reviewing stand watching the 1959 Admission Day parade in Sacramento were state controller Robert C. Kirkwood, a member of Observatory Parlor 177 (second from left), and U.S. Senator William F. Knowland, a member of Halcyon Parlor 146. Kirkwood, a native of Mountain View, was a member of the state assembly for seven years before serving as controller from 1953 to 1959.

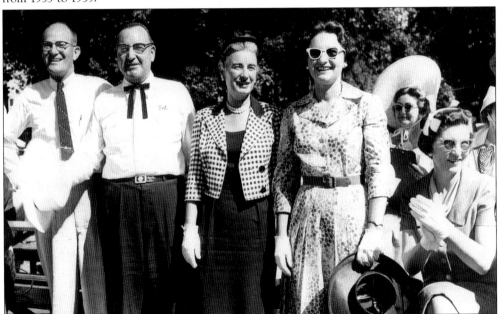

Edmund G. "Pat" Brown, a member of South San Francisco Parlor 157, was attorney general who was campaigning for governor when he donned this western garb for the 1958 Admission Day Parade in Sacramento. His wife, Bernice (dark glasses), rides beside him. A political coincidence is that all the Native Sons known to have been on the parade's reviewing stand lost their bids in the following November's election, yet those (like Brown and his South San Francisco Parlor compatriot, Assemblyman Charles W. Meyers) who participated in the parade won.

Six

STILL CELEBRATING

Just as the procession of California history progresses through the years, so do parades and other celebrations sponsored by the Native Sons of the Golden West. They are aimed at placing a spotlight on the grandeur of the state in which its members were born.

As the 21st century began, California celebrated its sesquicentennial birthday. As expected, the Native Sons were there, standing shoulder-to-shoulder with the state department of parks and recreation to help sponsor the largest living history display ever assembled, which occupied virtually all of Sacramento's Capitol Park. It featured everything from reproductions of Indian villages and Civil War encampments to a World War II–era USO show, gold-panning demonstrations, a Nike Missile, and the garage where William R. Hewlett and David Packard's experiments in the 1930s blazed pathways that led to the flowering of California's electronics industry.

There are not as many photos to show of Native Sons activities at the event because their role was one more behind the scenes than it had been in past celebrations. Nevertheless, it was a key function that was essential in making the event's logistics come together.

Most activities nowadays are not as visually dramatic as those staged in the early 20th century, but they are equally dedicated and committed. Times may change, and the methods of observance may transform along with them, but the Native Sons of the Golden West continues to celebrate California's statehood in a multitude of ways, such as marking and dedicating historic and civic sites or, of course, marching in parades frequently with their trademark 35- by 50-foot bear flag—the world's largest. Century in and century out, the Native Sons' enthusiasm and love for the Golden State never diminishes.

There was a time when a 75-year membership pin was unneeded as members simply did not survive that long, but that is no longer the case in this modern era. So the Board of Grand Officers commissioned a pin to commend those who had been members of the order for 75 years. The pin first became available for presentation in 2004. The recipient, on October 2, 2004, was Arthur Hecht of Mount Tamalpias Parlor 64, venerable song leader for many a Native Sons event, who received his pin from Grand President Barney Noel and then, naturally, led those assembled in a rousing rendition of "I Love You, California."

Joseph G. Fitzhenry, who had served as Sunset Parlor 26's president in 1943 and later as governor general of the Past Presidents Association, received his 75-year pin on June 10, 2005, with past junior grand president Barney Noel performing the honors. Another 75-year member who was honored as one of the first recipients the pin on November 21, 2004, was South San Francisco Parlor 157's John Flower. Flower, who was initiated on October 8, 1926, served as his parlor's president in 1961.

You don't have to be old to be a devoted Native Son. Scott Cullinane, who aspires to become a museum-exhibit designer, as a volunteer created a much-acclaimed temporary exhibit on World War II for Ramona Parlor 109's museum in the autumn of 2004. A few months later, the talented Cullinane celebrated his 18th birthday, and became a member and officer of Ramona Parlor.

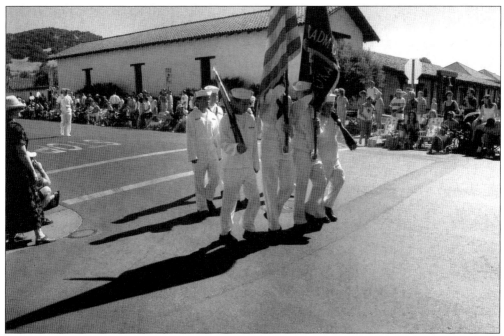

A number of Native Sons parlors support Scout troops and youth athletic teams. This Sea Scout Troop, sponsored by Napa Parlor 62, which assists in annual Flag Day ceremonies, is shown marching in front of Sonoma Mission. An increasing number of its members are "graduating" into Native Sons membership.

Although the name remains the same, it is no longer strictly true that all Native Sons are "sons." Women are admitted, not just to membership, but increasingly to leadership. In 2002, Marcia Skelton of Redwood Parlor 66 became the first woman elected to a parlor's presidency. As a statewide committee chairman, she strengthened the organization's publicity programs.

In 2003, Ola Addante was elected president of Ramona Parlor 109, becoming the second woman to head a parlor. She spearheaded a number of programs to bring her parlor more into public view throughout Los Angeles County, energizing efforts to mark landmarks in that region.

The Native Sons were not as visible to the public during the sesquicentennial celebration of California's statehood as they had been during the Diamond Jubilee or centennial. Nevertheless, they played an essential role behind the scenes. By providing staffing and support services, the Native Sons enabled its collaborator in the event, the California Department of Parks and Recreation, to present the largest living history display ever assembled in Sacramento's Capitol Park. And the organization's grand officers made a spectacular entrance via water, with some arriving on the historic fireboat, the *Phoenix*.

The Native Sons grand officers stand on the deck of the historic schooner, the *Alma*, which brought them up the Sacramento River to the opening ceremonies of the sesquicentennial celebration at Capitol Park.

Redwood Parlor 66, which owns a grove of redwood trees in San Mateo County, donated the redwood planks that were used to construct this 40-foot replica Chinese shrimp boat. The vessel was created through the joint efforts of China Camp State Park and the San Francisco Maritime National Historical Park.

A troupe of lion dancers perform as the recreated Chinese shrimp boat, *Grace Quan*, is launched on October 25, 2005, at China Camp State Park. Shrimping served as the livelihood of many of China Camp's residents from 1860 to 1910. Although lions are not native to China, because the animal is considered to represent courage, energy, and wisdom, for many centuries lion dances have been used on ceremonial occasions to extol good fortune.

This tranquil scene of a boat reconstructed through the assistance of the Native Sons of the Golden West, honoring California pioneers who came from China, would have been an improbable one in times gone by. Like all human organizations, the Native Sons has been a reflection of the times in which it has existed—for better and worse. It came into being in the mid-1870s, at a time of economic depression. It was an era when many Californians blamed hard times on the presence of Chinese laborers who had been brought to California to build the then-completed transcontinental railroad, and who remained as a source of inexpensive labor. The Native Sons was not exempt from mirroring those feelings.

For many years, the Native Sons, along with many of its most prominent leaders, ardently supported a series of Exclusion Acts designed to limit and prohibit the immigration of Asians to the United States. The organization campaigned for many years against the admission of Hawaii to statehood frankly because of fears that the new state's government would be controlled by people of Asian descent. Like many mainstream groups of the time, the Native Sons joined in advocating the relocation of Japanese and Japanese-American residents of the West Coast during World War II. (Ironically, many decades later, in an indication of changed views, a person who had endured that experience, Eddie Murakami, would be elected grand trustee of the Native Sons three times, beginning in 1990.)

As the launching of the *Grace Quan* exemplifies, times and attitudes are capable of changing for the better. In contemporary life, the Native Sons bars no one from its membership because of his or her ancestry. People of many backgrounds fill its ranks, not only of membership, but of leadership. People of Asian descent hold and have held its highest statewide offices, including, on one occasion, the grand presidency itself. Each native of California, whether his or her background can be traced to Asia, Africa, Australia, Europe, or the various parts of the Western Hemisphere, brings a heritage worthy of acknowledgement and respect for its specific contributions to history. As we celebrate California's statehood, we can also celebrate the reality that the arms of the Golden State are wide enough to embrace us all.

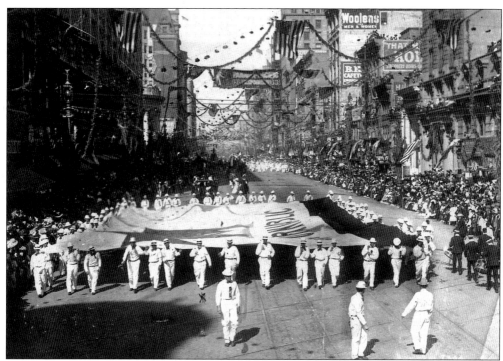

Sonoma Parlor 111 members carry a giant bear flag in San Francisco's 1900 Admission Day parade.

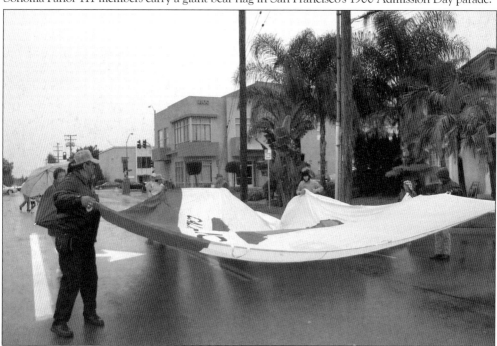

Members of Rio Hondo Parlor 294 and Santa Ana Parlor 74 carry the bear flag on December 5, 2004, in Downey's Christmas-season parade during a heavy rainstorm. Rain or shine, the Native Sons of the Golden West still celebrate California's statehood with an enthusiasm that can't be dampened after all these years!